THE CRITIC SEES
A Guide to Art Criticism

Sarah Gill
M.A., Ph.D., Columbia University

Front Cover: Giuseppe Arcimboldo, Aqua *(Water)*, ca. 1566.
(By kind permission of the Kunsthistorisches Museum, Vienna.)

Back Cover: Wassily Kandinsky, (Russian, 1866–1944), *Open Green*
(No. 263), 1923. (Oil on canvas, 38 ⅜ × 38 ⅜ in., F.1971.4.P,
The Norton Simon Foundation.)

KENDALL/HUNT PUBLISHING COMPANY
2460 Kerper Boulevard P.O. Box 539 Dubuque, Iowa 52004-0539

Table of Contents

Chapter 3 ▼ Realism in Space 35

Chapter 4 ▼ Formalism as a Universal Approach 53

Chapter 10 ▼ Portfolio of Art Criticism 157

List of Illustrations

Preface

This is a book that will help the novice art critic to see and to write about works of art. It is the first book to survey the theoretical foundations for art criticism, and to provide the definitions and approaches to art criticism that are foundational to the evaluation of works of art. It fills the gaps between and within the traditional surveys of art history that usually lack a systematic approach to the evaluation of art, and the art appreciation courses that are generally missing a theoretical foundation. Throughout the book, the focus is on the work of art, and on choosing the approaches and methods that will provide the best understanding of the work. It is based on actual sensory perceptions and not on the findings of Gestalt psychology. To make this book more accessible to West Coast students, the illustrations have been chosen wherever possible from West Coast museums and collections. A special feature is the portfolio of sample art criticism with commentaries at the end of the book.

The Critic Sees: A Guide to Art Criticism is designed to be especially helpful to two different kinds of novice critics: the students of art at academic institutions, and the journalists who have been assigned art as their beat. The book may be used as an adjunct to art history courses. It provides a fuller account of aesthetics than is usually possible in the standard art history text books, and it lays the foundation for a careful, systematic analysis of the work of art. Besides a thorough grounding in the three traditional approaches to art criticism, it includes a special chapter on preparing a term paper for art history courses. It is not meant to replace the many excellent guides to writing term papers. This book is devoted to acting as a guide to careful, systematic looking, in the belief that thorough analysis is necessary before writing. Journalists who use this book will be able to understand their own approaches to art, and those who take the time to follow the suggested analysis of the works of art before sitting down to write should find their reviews substantially improving. Journalists may also be interested in the opportunities for professional development listed in Chapter 9.

There were many people who made this book not only possible but necessary. Thanks go to all the students whose probing questions led to a realization that there were many theories and approaches left out of the text-

books. Much appreciation goes to all the professional art critics who continue to write reviews to the best of their powers year after year. Their reviews are a continuing education and an inspiration. Many thanks and much love to all the colleagues, friends, and kinfolk who have given generously of their time and expertise: Cindy Battershall, Don Bishop, Marty Carpenter, Kevin Fletcher, Frederick Jaya Gill, Jane Gill, Dave Harrigan, Jeane Hughes, Mary and Gayland Jordan, Ann Joergenson, Shirley Kotite-Young, Charlotte Olmsted Kursh, Michael Lanham, Sylvia Nance, Jon Nelson, Emory Norstad, Lynn Ostling, Greg Sanoff, Richard Speakes, and B. J. Young. And special thanks to Helen and Marv Sherak for many happy hours spent in their company in front of some of the world's best works of art.

Chapter 1

▼ ▼ ▼ ▼

Definitions and Approaches to Art Criticism

Art is long, life short; judgement difficult, opportunity transient.
—Goethe.

What is Art Criticism? Who Is an Art Critic?

Art criticism is the evaluation of art. It is your considered response to the work of art.

You become an art critic whenever you evaluate a work of art, whether you are commenting to a friend on the works you like best in a local gallery, preparing a term paper for your art history class, or writing a long review of a major urban exhibit for the San Francisco *Chronicle*, *Artweek*, *Artforum*, *Time*, or the *New York Review of Books*.

Art criticism does not automatically mean finding fault with a work of art. A good critic tries to look at the work as carefully as possible before judging it. The kind of hasty critic who sounds off without responding carefully was ridiculed 30 years ago by the Pop artist Jasper Johns who replaced the eyes with two open mouths on a sculpture and sarcastically entitled it: *The Critic Sees* (**Figure 1.1**). Don't miss the point of the sarcasm. A good critic tries not to let the mouth substitute for the eyes. Hasty mouthing off is not a new complaint about critics; more than 2400 years ago, the Greek painter Zeuxis is supposed to have remarked: "Criticism comes more easily than craftsmanship." This book will help you to look more carefully at a work of art by means of the approaches provided in the chapters that follow.

After careful looking, good criticism means judging the quality of a work of art according to the best of your ability, experience, and education. While everyone's ability and experience differ, you can always improve your evaluation of art by increasing your knowledge of the different approaches and methods of art criticism. How to choose the best approach is the next question.

Why Choosing the Best Approach to Art Criticism Is Not Simple

There are two variable factors that prevent a simple answer to this question.

One is you, the art critic: your personal responses to art will be rooted in all the unique abilities and experiences that make up your own individuality, and will influence your choice of an approach or method.

The second variable factor is the work of art to which you are responding. It is made by a human like you, and like you, may be complex and may be capable of analysis at different levels, each of which may be correct in its own way. For example, take a look at the painting called *Aqua (Water)* by the Italian Mannerist artist, Giuseppe Arcimboldo, that is reproduced on the front cover. You will find that it can be visually interpreted in two ways, both of which are correct.

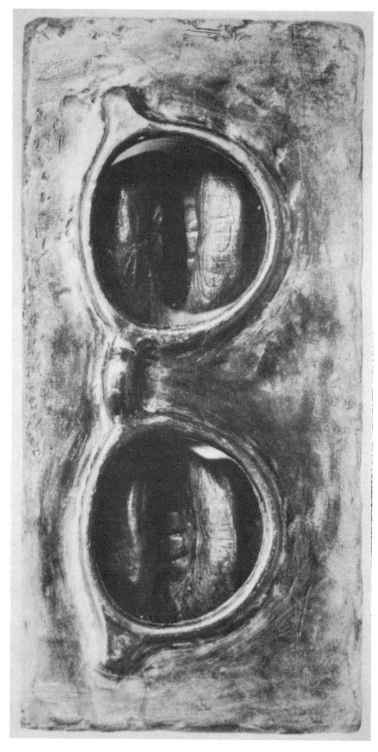

Figure 1.1 ▼ Jasper Johns, *The Critic Sees* (1961). Private Collection. (Copyright © 1991 Jasper Johns/VAGA, New York, 1991.)

Two Views of Arcimboldo's *Aqua*

Arcimboldo's *Aqua* is a sample of what is known as a double image. You could also call it an "art pun," or a play on visual forms. It is two pictures in one. Examine the painting to see what you can find in it. If you focus on it from a distance of about 18 inches from the surface of the reproduction, you will probably be able to see dozens of glittering eyes staring back at you. Keep looking. These eyes belong to numerous forms of sea life crowded together, for example: an otter, a walrus, a seal, a seahorse, all kinds of fishes—including a moonfish, a catfish, a trout, a manta ray, and an eel; a shark, a fresh green lobster, and a squilla (a kind of Italian prawn); another lobster, a shrimp, and a crab—all boiled pink; a squid, a cuttlefish, and an octopus; a turtle, a frog, a nautilus shell, a scallop shell, sprigs of pink coral, and a few pearls. You may be able to identify additional forms.

In some ways, these forms of sea life are convincingly lifelike. Each is shown as a three-dimensional form, that is, painted with highlights and shadows, and there are also many details of contrasting textures, such as fur, fins, scales, antennas, plates, teeth, and the glassy eyes. But there are also ways in which these items of sea life are not realistic. We have already noted the boiled creatures painted right next to the fresh ones. This is not something one would usually find in nature. The way that the sea creatures are shown crammed together into a seething, crawling mass, without attacking one another, is not realistic. In addition, despite the title of the painting, there is not even a splash of their watery habitat painted around them. Then the creatures are not painted to a consistent scale. The crab is gigantic compared to the shark; the seal is shown the same size as the sea horse. Finally, one of the pearls has a gold fitting attached to it, and the other pearls are strung together like a necklace.

A necklace? Step back and look at the reproduction from about three feet. Unfocus your eyes, if necessary, to blur the textural details, and what do you see? You should be able to make out a human head in profile, facing left, with the shark's red mouth as the lips, the squilla as the eyebrow, the sprigs of coral as hair escaping from a headdress, the boiled pink shrimp on the right as a tuft of hair at the back of the head, a pearl earring hanging from a shell ear, and a rope of pearls around an eely neck. How is it that you are able to make out this profile head? Because the artist has carefully arranged and packed the sea creatures into a solid mass with a profile suggestive of a human head, and then painted on this mass broad highlights and shadows to create the illusion of an eye socket, forehead, nose, cheek, chin, neck, and shoulder. He was probably influenced by the example of Leonardo da Vinci who, working a generation earlier in Arcimboldo's home town of Milan in northern Italy, had perfected the use of highlights and shadows in the figures of his *Last Supper*. So in one and the same painting you can see both a crowd of sealife and a bejewelled head. Both visual interpretations are correct. Keep this in mind as you investigate the different approaches and meth-

ods of art criticism. You may want to use more than one approach to help you to understand different aspects of the work of art.

Now that you have seen these two ways of looking at Arcimboldo's *Aqua*, other kinds of questions may begin to occur to you. For example: Is this a male or a female head? Is the painting a portrait of a real person? Why did the artist choose to paint a double image? Did he paint other double images? What does this painting mean? Answers to these and to some other questions that you might have about this puzzling work of art will be found in the discussion of its meaning in a later chapter.

Aesthetics: Three Traditional Definitions of Art

Before going on to the introduction of different approaches and methods of art criticism in this chapter, we should take a moment to consider exactly what we mean by "art." The definitions that follow are some of the traditional ways in which art and the work of art have been defined by the specialists in a particular branch of philosophy, called aesthetics.

Aesthetics is the branch of philosophy that is concerned exclusively with all the arts. Like the word "art", the term "aesthetics" has deep roots in our cultural history. It comes from a Greek word that means "to perceive." Philosophy is the attempt by philosophers to systematize human thought and knowledge in various areas. The philosophers of aesthetics, called aestheticians, have thought and written about art for nearly 2500 years, since the days of Plato in Athens, and have provided definitions, discussions, and approaches that are valuable for art critics. In particular, aestheticians have concerned themselves with two issues: the definition of art and the definition of an art object. We will consider the definition of art first. Before reading further, you will find it helpful to try to give your own definition of art. In your opinion, what do you think art is? What makes something a work of art? What do you think is the purpose or goal of art?

While you are formulating your answer, please note that this is a very important question, because your answer will reveal what you currently believe is the most important approach to art criticism. There are no wrong answers. It's useful at this point for you to find out what your own beliefs actually are.

Now take a look at your definition. Chances are you may have said something like one or more of these three basic definitions of art, or like the statements listed under them.[1] If not, keep reading, as your definition may be covered in the discussions that follow.

Three Approaches to Art Criticism

1. Realism

Definition: **Realism is the representation of reality**

Here are some sample statements from the approach of realism: "Art is a picture of reality." "A representation of what the artist sees." "A work that an artist has brought to life."

2. Formalism

Definition: **Formalism is the quality and arrangement of forms**

These are sample statements made from the approach of formalism: "Art is what is beautiful." "Forms pleasing to the senses." "Created shapes that give pleasure to others."

3. Expressionism

Definition: **Expressionism is the expression of meaning**

Sample statements made from the approach of expressionism: "Art is the expression of emotion." "Expressing oneself." "Art is the expression of the artist's imagination and dreams." "A cultural creation of painting, sculpture, or architecture." "Art reflects a culture and is an index of how people see the world around them." "The creative expression of individuality, beliefs, history, and attitudes."

How do these definitions work? Each one of these basic categories of definitions is based on a different approach to the evaluation of art. At a fundamental level, your definition of art is really your approach to art and how you evaluate art. In order that you may be able to begin to differentiate these three approaches, we will provide three brief evaluations of the same work of art, using each approach in turn. This is just to introduce the approaches. We will be spending much more time on individual approaches and methods in the following chapters.

Three Evaluations of Picasso's *Guernica*

Using each of these approaches—realism, formalism, expressionism—we will evaluate Picasso's *Guernica* (Figure 1.2). This is a large oil painting (11 ½ × 25 ¾ feet) made in Paris in 1937 by Pablo Picasso to protest the destruction of the town of Guernica in northern Spain at the time of the Spanish Civil War. It is now in the Museo del Prado in Madrid.

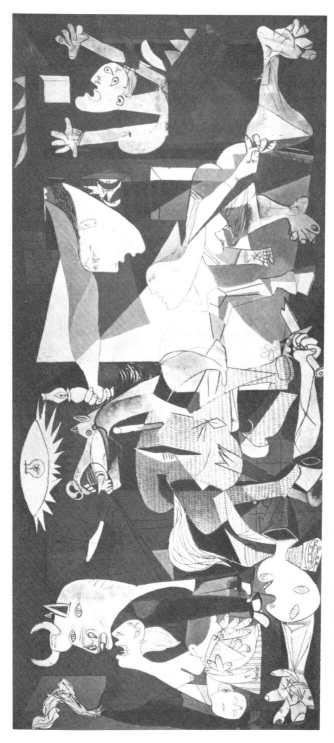

Figure 1.2 ▼ Pablo Picasso, *Guernica* (1937). Museo del Prado, Madrid. (Copyright © 1992 ARS, NY/SPADEM.)

7

Approach of Realism

First, an evaluation of *Guernica* using the approach of realism. This approach judges art on the basis of whether or not the forms or shapes in the work of art are convincingly close representations of what we can see or touch in real life. Now to look at the identifiable forms in this painting. Starting at the left of the painting, there is a large bull, body facing right and head turned to the left above a weeping woman who holds a dead child. A hollow head and one of the arms of a broken statue lie on the ground in front of the woman and child. Another hollow arm lies along the center in the painting, its fist clenched upon a sword with a broken blade. Above the broken sword, and beneath an oval sun (or street lamp) with a light bulb at its center, is a screaming horse, from whose open mouth jut teeth and a pointed tongue. The body of the horse, which is slashed and pierced by a broken spear, is covered in places with long lines of parallel marks. To the right of the horse are two female figures, one leaning from a window with her outstretched arm holding a lamp aloft, the other running on huge feet. At the far right of the painting, beneath a window in a burning house, is a woman with open mouth and outstretched arms who falls with her dress in flames. There is a small flower above the broken sword and a bird between the heads of the horse and the bull.

These forms are identifiable because some of their outlines and proportions are more or less as we perceive them in reality. But could we call the figures realistic? Clearly not. No textural representations of soft hair or hides, no consistent use of light and shadow, no consistent perspective. It is not possible to identify clearly whether it is day or night, indoors or outdoors. Other unrealistic features: huge hands and feet; eyes displaced beneath or above the ears; flat bodies, disappearing bodies; the bodies, flames, and sun painted not in realistic colors but all in black, white, and different greys. You may be able to add to this list more unrealistic features that you have observed in the painting. If we were judging *Guernica* solely from a realistic point of view, we would have to grade it with a "C" or "D".

Approach of Formalism

But let's look at *Guernica* using the approach of formalism. In this approach, we look strictly at the quality and arrangement of forms and put aside considerations of realism or meaning. By forms we mean the shapes and colors of a work.

Looking first at the *quality* of the forms, we see numerous clearly defined, sharp, flat, triangular shapes: the bull's ears, the sun's rays, the tongues of the screaming woman and horse, splinters and spear heads, highlights on a door, nipples, necks, knees, flames. Part of the quality of these shapes in

Guernica is their clarity of outline. Then, noting their arrangement, we see that these shapes create a rich, ordered rhythm across the canvas.

Rhythms are repeated shapes in a work of art. They provide an important way for an artist to create order in the work. Great artists usually create numerous and complex rhythms of repeated shapes. As we continue to examine *Guernica,* we shall see more rhythms of shapes. For example, there is another rhythm of thick round sausage-shapes in the human fists and feet evenly displayed across the canvas from left to right; another in the linear ovals of the eyes, sun, and lamp flame; another rhythm in the careful placing of animal and human heads; and more rhythms established by the shapes and distribution of the patches of black, the patches of white, and the patches of different greys. These rhythms are complex and pleasing to the eye.

There are many other formalist concerns that could be discussed here, but the rhythms alone are enough for us to evaluate this painting very highly from the point of view of formalism. Solely on the basis of these rhythms of clearly defined shapes, we would have to award *Guernica* the top grade of an "A."

Approach of Expressionism

Now to judge the painting from the point of view of its expression of meaning. We will be helped in this approach by a thorough study of the painting by Herschel Chipp, a professor emeritus of modern art history at UC Berkeley, who developed some fresh interpretations of *Guernica* by relating the images in the painting to events in Picasso's private life. Chipp carefully documented his interpretations by means of his observations of relevant details in Picasso's other works, and by facts he accumulated through patient research in the vast bibliography of published articles and books relating to *Guernica.*[2]

You will find that the approach of expressionism requires more words than the approaches of realism or formalism. This disparity in length is generally the case when the work of art refers to a great deal of known history, mythology, sociology, or other kinds of sources that must be provided in order to make clear all of its multiple levels of meaning. Great works of art are usually very complex, with many levels of meaning.

Spanish Civil War the Source for Guernica

There is no question that Picasso painted this picture in outrage against the militaristic threat to the Republican government in the Spanish Civil War. On April 26, 1937, the town of Guernica in the industrial north of Spain was destroyed and the roads leading out of it machine-gunned by planes sent by Hitler and Mussolini to help in the overthrow of the liberal Republican government that had been elected to power the previous year. The insur-

gents, supported by Hitler and Mussolini, were the conservative Nationalists, led by Generalissimo Franco. By April 28, the radio and newspapers in Paris, where Picasso had lived for years, were full of the story, and three days later, on May 1, Picasso made the first sketches for *Guernica:* a bull, a horse, a woman with a lamp, and a fallen Classical warrior. He began painting it on May 11 and completed it shortly after June 4, 1937. Later, when the painting was exhibited in the United States, Picasso said that in *Guernica:* "I clearly express my abhorrence of the military caste which has sunk Spain in an ocean of pain and death."

Images of Victims

The images of *Guernica* are complex in their meanings, but two broad categories can be identified: the images of victims and the images of peace. Three of the figures in *Guernica* appear to refer to victims in the specific disaster of the bombing and strafing of the town: the woman and dead child, the running woman, and the woman falling from a burning building. But the other figures, the images that Picasso began with—a bull, a horse, a woman with a lamp, and a fallen Classical warrior—refer to victim images with complex associations drawn from Picasso's private life and passions. The bull and the horse refer in part to male-female conflicts in Picasso's life. Chipp points out that Picasso's etchings of a few years earlier, depicting a passive nude blonde in scenes with a bull trampling an agonized horse, actually referred to fights with his wife, Olga, over his new blonde mistress, Marie-Thérèse Walter. In part, however, the bull and horse also refer to Spanish bullfighting, a lifelong passion of Picasso's, in which both animals were victims, the horse being routinely gored by the bull and the bull being dispatched by the matador. In *Guernica*, the horse has not been gored, but has been thrust through by a human weapon, to make clear that the destruction we see was the result of human action. The bull stands protectively over the woman and dead child, its human eyes painted to resemble Picasso's own eyes, staring out of the picture as if to engage the viewer. The fallen warrior refers again to the passive figure of Picasso's mistress as victim. Picasso originally sketched another passive female victim with a flower in her hair, lying next to the fallen warrior, but painted her out. The only remnant of that figure in the final version of the painting is the flower above the warrior's fist.

Images of Peace

The images referring to peace are more difficult to identify. The bird between the bull and horse could be interpreted as a dove of peace, except that it was not intended to be a symbol, according to Picasso, who said he couldn't remember what it was but thought it was just a chicken or pigeon! The woman whose extended arm holds a lamp refers to etchings Picasso

made earlier of his mistress as Lysistrata, a Greek woman, who made peace between the Athenians and Spartans, and whose arm is held out in a peace-keeping gesture. The extended arm also refers to the gesture of the artist, as seen in other sketches made by Picasso of a painter and model. With its associations of peace and creativity as opposed to destruction, this gesture seems like a beacon of light in the midst of *Guernica's* horrors of war, and indeed the hand holds a lamp. The same gesture was commemorated in Picasso's sculpture of a woman with a vase that was placed next to *Guernica* when it was first exhibited in Paris. After Picasso's death in 1973, this sculpture with extended arm was placed on the artist's grave.

As Chipp notes, Picasso's figures are "open, allusive, and subject to metamorphosis." Consequently, there are many other levels of understanding that we could reach here if we were to explore the painting further on the basis of Chipp's extensive study. But enough has been said for you to begin to grasp the rich complexity of meaning expressed in Picasso's *Guernica* (apart from the bird). *Guernica* should be awarded the top grade of "A+" for its complex expression of meaning.

From these brief evaluations, it should be clear to you that different approaches should be considered for a work of art. We awarded grades to Picasso's painting on the basis of each of three approaches to the work of art, but really the grades should go to the approaches. You were able to see that the approach of realism did not help you understand Picasso's *Guernica* as much as the approaches of formalism and expressionism. For other works of art, the approach of realism will be more helpful, and as we shall see later, many art critics today use this approach.

What Is a Work of Art?

Before going on to a deeper exploration of these approaches and methods, we should pause for a moment to consider the universal nature of a work of art. Like the definition of art itself, the definition of a work of art is a major concern of aestheticians. The definition that follows is not a consensus, but one point of view.

The making of art is a very old human activity, and seems to be one of the particular activities, like tool-making, that helps to distinguish people from animals. From earliest times, people have chipped out blades and points, made sculptures of women and animals, and painted animals and abstract signs on the walls of caves in Europe, Asia, Africa, and the Americas long before they recorded their written languages; in fact, the symbols and signs of most of humanity's forms of writing began as little pictures. To these early people, art-making appears to have been a special kind of activity. It was not random. To the Indo-European ancestors of English, the basic root-word of "art" meant "to fit together." The word "art" has many cousins in English that come from the same root: harmony, order, coordination, adorn,

ornament, reason, rite, ratio, arithmetic, and logarithm.[3] These terms all imply a kind of deliberate and systematic arranging into order by people.

Definition of a Work of Art: Anything People Arrange into Order

Perhaps we could use some of this historical information to begin a definition of art by saying: **a work of art may be anything people arrange into order.** Now let's see how you would apply this definition. In your opinion, would this definition of the work of art as something that shows deliberate and systematic arranging by people exclude any of the following: a painting? a bed? a sunset?

If you said that it would exclude a sunset, but not a painting or bed, you would be correct. A sunset is not arranged by humans. But, as we shall see later, it is possible to have an aesthetic response to a sunset, as well as to many other natural occurrences: sparkling rivers, leafy vineyards, foamy shores, azure skies, an iridescent dragonfly, a tiny, perfect seashell. Don't stop enjoying your responses to these beauties of nature. They are excluded as art only because they are not made by humans. The discussion of aesthetic responses in Chapter 4 may even help you to appreciate natural beauty more deeply.

If you said that this definition would exclude a bed, think about it. You may be putting a functional, cultural, or aesthetic limitation on the definition that doesn't need to be there. Isn't a bed something that shows deliberate and systematic arrangement by people? Well, yes, you might say, "but it isn't a work of art!" Would you be thinking, perhaps, that a work of art must be a painting, a sculpture, or a work of architecture? If so, you would be putting a *functional limitation* on the definition as given above, the same limitation as critics who have said that the only real or "pure" work of art was one which was made to be enjoyed as art, with no other function. Art for art's sake! But the trouble with this functional limitation is that it is too restricted. The French cabinet made about 1680 with designs in ebony, pewter, and tortoiseshell veneer, supported by statues of Hercules and his temporary consort Omphale, that is shown in **Figure 1.3** seems to deserve in its complexity to be called a work of art, even though it is a piece of furniture. What about architecture? Isn't architecture a medium of art that is made to be used as well as viewed? Of course it is. What about Gothic paintings and sculptures of Christ and the saints? These were intended to serve primarily as a focus of worship. There is a *cultural limitation* here too. Painting, sculpture, and architecture are traditionally important in the Western world, but ceramics and textiles are not, while in Asia, the ceramics of China and textiles of India have been important since the foundation of these civilizations. Some aestheticians would put an *aesthetic limitation* on the definition of the work of art, and say that the work of art must be something that evokes your

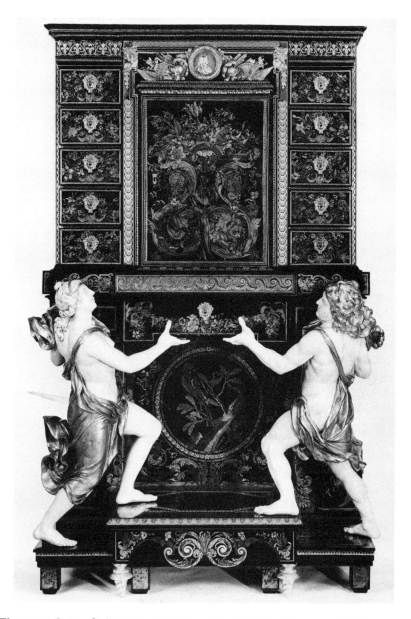

Figure 1.3 ▼ Collection of The J. Paul Getty Museum, Malibu, California. Attributed to André-Charles Boulle, and medallions after Jean Varin. *Cabinet on Stand* ca. 1675–1680. (Oak veneered with ebony, pewter, tortoiseshell, brass, ivory, horn and many stained woods; lignum vitae drawers; painted and gilded wood; bronze mounts. H: 7 ft. 6 ½ in.; W: 4 ft. 11 ½ in.; D: 2 ft. 2 ¼ in.; [H: 228.5 cm; W: 151.2 cm; D: 66.7 cm.])

aesthetic response. Not all aestheticians and critics define the aesthetic response the same way. Roger Fry thought that the forms of a work of art were adequate only to stimulate a "clear disinterested contemplation" and that knowledge of the purpose of the artist was necessary for a proper aesthetic judgement. We will be defining the aesthetic response in Chapter 4 as something that includes the response to an order created by people. Thus we will say here that all works showing a deliberate and systematic arranging by people are capable of evoking your aesthetic response.

Judgment Necessary to Evaluate Quality of Art Object

But just because every object that shows deliberate and systematic arranging by people may be regarded as a work of art, this does not mean that you should regard these objects indiscriminately. Normally, in our civilization, a bed is not as great a work of art as a painting. Our concept of art is something like the concept of political equality expressed in the Declaration of Independence. That document assumed us all to be "born equal." This is taken to mean that all Americans are born politically equal, but it does not guarantee that we each will be born with the same abilities or have the same experiences in life. This holds true for this definition of art. While all objects showing deliberate and systematic arranging may be potentially regarded as art, you will still need to use your judgment to determine which objects reveal the special qualities that will make you want to examine them more closely. You may find objects worthy of your close attention that are not in museums or otherwise identified as works of art. You will improve your judgment when you learn to use the different methods and approaches in the following chapters. And it will be helpful to take along with you the advice to critics by the German poet, Johann von Goethe, that is printed at the head of this chapter: "Art is long, life short; judgement difficult, opportunity transient."

Notes

[1]The terminology for these three definitions may be found in Victor Burgin's *The End of Art Theory: Criticism and Postmodernity* (Atlantic Highlands, N.J.: Humanities Press International, 1988), p. 144. The three definitions as given in the text above have been adapted from the categories provided in Harold Osborne's *Aesthetics and Art Theory: An Historical Introduction* (New York: Dutton, 1970), pp. 17–24. Osborne called his categories "Naturalistic," "Formalistic," and "Instrumental." The statements following the definitions are selected from informal surveys of approximately 5000 art history students over a period of 21 years.

[2]Herschel B. Chipp, *Picasso's Guernica: History, Transformations, Meanings* (Berkeley: University of California Press, 1988). Chipp's bibliography, a 25-page compendium of cultural and historical background materials, books and articles on Picasso and *Guernica*, and catalogues of exhibits, provides an excellent resource for further exploration of this painting.

[3]For other words related to "art", see the entry under "ar-" in "Indo-European Roots," *American Heritage Dictionary* (Boston: Houghton Mifflin, 1981) p. 1506. There are a few curious words deriving from later usages of the root that would be difficult to assimilate into a definition of art, such as arms, army, hatred, and kindred.

Further Reading

Victor Burgin. *The End of Art Theory: Criticism and Postmodernity*. Atlantic Highlands, N.J.: Humanities Press International, 1988.

Margolis, J. *The Language of Art and Art Criticism: Analytic Questions in Aesthetics*. New York: Doubleday, 1965.

Object-Image-Inquiry: The Art Historian at Work. Santa Monica: Getty Art History Information Program, 1988.

Harold Osborne. *Aesthetics and Art Theory: An Historical Introduction*. New York: Dutton, 1970.

Chapter 2

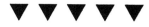

The Question of Realism

*That painting is most praiseworthy which conforms most
to the object portrayed.* —Leonardo da Vinci

Illusionism is the basis of every artistic experience. —H. W. Janson

▼ The Question of Realism ▼ Magritte's Pipe
▼ The Nature of Reality: Phenomenology and Idealism
▼ Plato's Version of Idealism
▼ Idealism Incompatible with Realism in Art
▼ The Greek Revolution in Realism
▼ Five Methods to Create Realism in Objects
▼ 1. Profile (Contour Line) ▼ 2. Proportions ▼ 3. Texture
▼ 4. Foreshortening ▼ 5. Highlighting (Modeling)
▼ How Much Realism Is Enough?

The Question of Realism

Realism is both the simplest and the trickiest of the approaches to art. It is the simplest because it seems to involve no preparation, no lengthy analysis, no library work. All you need to do is to look at the work of art and decide whether or not it is realistic. For example, look at *The Betrayal of Images* (Figure 2.1) by the French surrealist painter, René Magritte, and decide for yourself whether or not this painting of a pipe is realistic. You might want to begin to think why.

Magritte's Pipe

You probably decided that Magritte's painting of a pipe is realistic, perhaps because of its profile which looks like that of a pipe and gives the recognizable proportions of a pipe, its smooth, well-polished surface, and the way it is made to look three-dimensional by the use of foreshortening and highlighting. But the artist has carefully lettered in a caption that seems to deny its realism: "Ceci n'est pas une pipe." "This is not a pipe." Magritte is reminding us that however realistic his painting of a pipe may appear, it is not a real pipe. That brings us to the tricky part. If we are going to evaluate art using the approach of realism, we will need to know, first of all, what reality is before we can compare a work of art to it, and secondly, how much of that reality must be represented in the image before we will accept the image as realistic.

The Nature of Reality: Phenomenology and Idealism

We will begin with the nature of reality. If Magritte's pipe is not a pipe, but a painting, then what do you think a real pipe is?

If you say that a real pipe is an object that you can see or touch, then you have a particular view of reality that philosophers call **Phenomenology**, after "*phenomenon*," *something that can be perceived by the senses*.[1]

If you say that a real pipe is a mental or spiritual conception of a pipe, then your view of reality belongs in the vast realm of philosophy called **Idealism**, *after "idea," a mental conception.*[2] Neither view is wrong, but your choice will affect what you consider to be realistic in art, and, of course, will ultimately affect your judgment of the art. For example, if you choose Plato's version of Idealism as your view of reality, and follow the Socratic reasoning that Plato puts into the mouth of his teacher in the following selection from the *Republic*, you will end up like Socrates's student, believing that it is impossible for any art to be realistic, because only the Ideal is real.

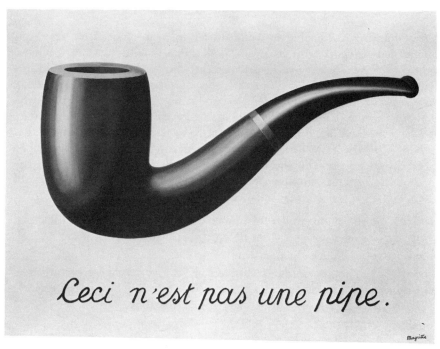

Figure 2.1 ▼ The Betrayal of Images (1929) by René Magritte. The caption underneath the pipe reads: "This is not a pipe." (*La Trahison des Images [Ceci n'est pas une pipe],* museum number 78.7, Los Angeles County Museum of Art, purchased with funds provided by the Mr. and Mrs. William Preston Harrison Collection.)

Plato's Version of Idealism

Plato, the first philosopher in world history to write on aesthetic concerns, dramatized his work with dialogues to illustrate how his teacher, Socrates, would use carefully directed questions to get the answers he wanted. In this important passage from Plato's *Republic*, Socrates is presented as if conducting a lesson with some young students on the concept of the Ideal and on the imitative nature of art. This dialogue is set in Athens in the late 5th century B.C., and they are discussing the reality of beds, not pipes. In addition to observing the view of reality given here, you might be interested in trying to get behind the words of the dialogue to see what kind of an attitude the author has towards painting. What do you think he believes the goal of painting is? Do you think he approves of this goal?

Socrates: Beds, then, are of three kinds, and there are three artists who superintend them: the Creator, the maker of the bed, and the painter?

Student: Yes, there are three of them.

Socrates: The Creator, whether from choice or necessity, made one bed in nature and one only; two or more such Ideal beds neither ever have been nor ever will be made by the Creator.

Student: Why is that?

Socrates: Because even if he had made but two, a third would still appear behind them which both of them would have for their Ideal, and that would be the Ideal bed and not the two others.

Student: Very true.

Socrates: And what shall we say of the carpenter—is he not also the maker of the bed?

Student: Yes.

Socrates: But would you call the painter a Creator and maker?

Student: Certainly not.

Socrates: Yet if he is not the maker, what is he in relation to the bed?

Student: I think that we may fairly designate him as the imitator of that which the others make.

Socrates: Good; then you call him who is third in the descent from nature an imitator?

Student: Certainly.[3]

Idealism Incompatible with Realism in Art

Plato has made it clear in this dialogue that he believes that the only real bed is the Ideal bed. You cannot see or touch an Ideal bed. It exists only as a mental or spiritual conception, an abstract lying behind the concrete objects

made by carpenters. The carpenter's bed merely imitates the Ideal and is therefore two steps away from reality. And because the bed in the painting imitates the carpenter's bed, it is three steps away from reality. From this you may have figured out that Plato believed the goal of the painter was imitation; and that he scorned the painting for being three times removed from the abstract Ideal which to Plato was the only reality. He once compared a painter to someone whirling around with a mirror, capable of capturing only the appearance of things, not what Plato considered the reality. But even though Plato's Idealism was incompatible with realism in art, it continued to be used as a basis for criticizing art.

Plato's Idealism provided the foundation, for example, of the rules for painting embodied in the work of the French artist, Nicolas Poussin, in the 17th century and in the lectures on his art at the French Academy: the painter must strive for the general and ideal and avoid the particular. Painters should stress line drawing and be careful with the use of color, which was considered too sensual.[4] These academic rules, founded on Plato's Idealism, remained as the basis of art criticism for centuries. In London in the 18th century, Sir Joshua Reynolds, who was President of the British Royal Academy of Art, praised a history-painter for painting "man in general" and belittled a portrait-painter for painting "a particular man, and therefore a defective model." In New York in 1987, the *Time* art critic Robert Hughes said the problem with Julian Schnabel's paintings was that "Schnabel has never learned to draw."

The Greek Revolution in Realism

It is one of history's ironies that Greek artists completely ignored Plato's concerns with the abstract Ideal, because they were engaged in the greatest revolution in realism in art that the world would ever know. Their goal was indeed, as Plato noted, to imitate reality, but their reality was not Plato's Ideal. They were concerned with representing what they could see and touch. They did not call themselves Phenomenologists, but their concerns were nevertheless with sensory phenomena. Take another look at Magritte's painting of a pipe. What made you think it looks realistic? We suggested five methods that were used by Magritte to make the pipe look real: its profile, its proportions, its surface texture, its foreshortening, and its highlighting. Of these five methods used to create realism in objects, Greek painters invented three: texture, foreshortening, and highlighting. Before the Greeks, the usual way to depict an object was simply through its profile and its proportions. Greek painters also revolutionized the depiction of space. But first we will discuss the different methods used to create realism in objects. Most of the examples shown below will be paintings, but you should realize that the methods used to create realistic objects in paintings may also be successfully

used to create realistic sculptures, and we have used a few sculptures as examples of realism in objects.

Five Methods to Create Realism in Objects

1. Profile (Contour Line)

Profile means the outline of the object. Another word often used for profile is **contour line.**

The profile or contour line defines the edge of the object. You can see that Magritte's pipe has a sharply defined profile. A profile is the oldest method in human art to create a three-dimensional form. It occurs in cave paintings throughout the world, and it was used extensively in Egyptian painting before the Greeks. It continues in heavy use around the world in art that remains uninfluenced by the Greek revolution in realism. If you look carefully at the Native American blanket below **(Figure 2.2)**, you will see a triple profile, created by sewing three rows of mother-of-pearl buttons that define the edge of the three-dimensional frog. Another triple row is used for a border around the blanket. Note that, despite the use of outlining, the animal looks flat. That is because the limbs are shown in profile, with the head and torso presented full view. You will find the same kind of flattening done to human figures in these traditions outside the influence of Greek realism.

2. Proportions

Proportions refer to the relationship of the parts to the whole.

Look at the comparative sizes of the bowl and the stem of Magritte's pipe. They seem to correspond to the relative sizes or proportions of the standard old-fashioned briar pipe, but of course, your judgment concerning the realism of the proportions of Magritte's pipe will depend on whether or not you have had some experience of a pipe of this sort. You will be more readily able to judge the realism of proportions in art that represents the human figure. Take, for example, the male and two female figures in bronze entitled *L'âge mûr (Maturity)* by the French sculptor Camille Claudel shown below **(Figure 2.3)**. Claudel, who was the student and one-time mistress of the sculptor Auguste Rodin, has shown herself as a young nude figure kneeling in vain supplication to a nude male figure representing the aging Rodin, who is being reclaimed by his former mistress, shown as a partially draped older woman. You can judge from your own experience with human figures that the proportions of these three figures appear to conform to ordinary human proportions, as you can by looking at the relative sizes of heads to torsos, fingers to hands, hands to arms, toes to feet, feet to legs, arms and legs to torsos. In their proportions, then, Claudel's figures are realistic. By way of comparison, look at the nail fetish figure made a century ago by an unre-

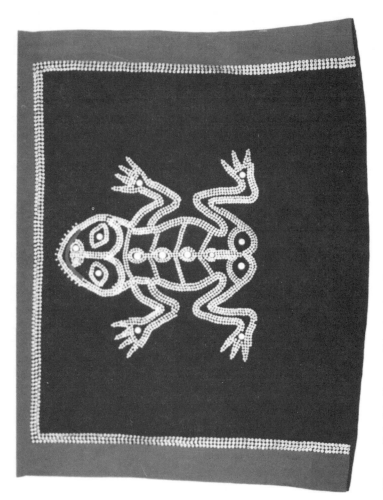

Figure 2.2 ▼ *Button Blanket* by Tlingit Tribe, c. 19th century. (Wool and buttons, courtesy of the Thomas Burke Memorial Washington State Museum, catalog number 1-1495.)

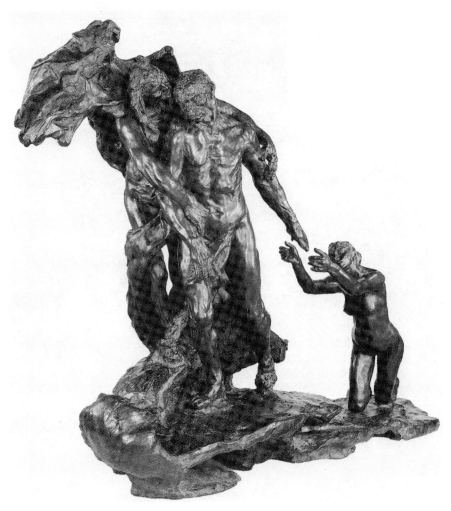

Figure 2.3 ▼ Camille Claudel, *L'âge mûr (Maturity)* 1899–1903. (By kind permission of the Musée d'Orsay, Paris.)

corded artist of the Bakongo people of Zaire in Africa, and studded with nails to indicate its power **(Figure 2.4)**. You can see that the head is much larger in proportion to the torso than any of Claudel's figures, and is therefore not as realistic.

3. Texture

Texture means the way a surface is given highlights and shadows to suggest a tactile quality.

Magritte's pipe is given broad areas of highlights and shadows to suggest a highly polished smooth surface. Other kinds of contrasting textures are provided in the example below of a Dutch 17th-century painting by Gabriel Metsu, where there are four distinct kinds of textures lined up at the front of the painting **(Figure 2.5)**. Starting from the left, we see: a soft knotted-wool Turkish carpet draped over a table, a little dog with silky feathers of hair sprouting from his body, a huge expanse of thick, crumpled white satin skirt, and a polished wooden viola da gamba. Metsu creates each of these distinct areas of textures by the different ways in which he applies shadows and highlights, for example, with short broken areas of highlights for the crumpled skirt, and with broad smooth areas for the viola da gamba. These areas of strongly contrasting textures make the painting vividly realistic. If you are able to look at this actual painting in San Francisco, or at others with similarly contrasting textures, you will feel your fingers wanting to touch the surface of the painting. You may also find contrasting textures used to create realistic sculpture; for example, the marble bust of George Washington done by the French sculptor, Jean-Antoine Houdon **(Figure 2.6)**, is carved into thin, irregular ridges at the head to suggest the texture of thin locks of hair, and it is carved into broad, flat ridges at the shoulder to suggest the thick folds of a cloak.

4. Foreshortening

Foreshortening is the changed appearance of an object when it is viewed from different angles.

You can see the circular opening of Magritte's pipe is shortened to a thin oval to make it look as if it were receding in space. The mouthpiece is on a slight slant to suggest that the pipestem is pointed slightly away from the viewer. You can see another good example of foreshortening in the painting of the happy lovers by the French artist, Jean-Honoré Fragonard **(Figure 2.7)**. The young man, who is shown holding a dove that symbolizes his devotion, gazes adoringly up at the young woman who dangles a birdcage above him to symbolize how she has captured his love. The thighs of the young man are foreshortened into creased round shapes on the surface of the painting. You know from looking down at your own thighs that they are

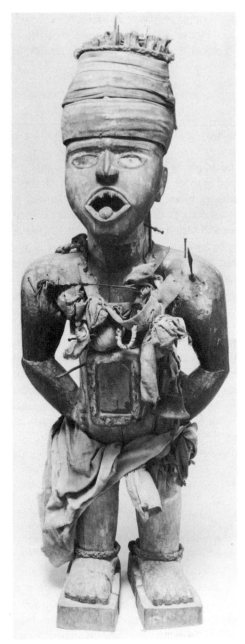

Figure 2.4 ▼ *Nail and Blade Oath-Taking Image (Nkisi N'Kondi),* Kongo, coastal Zaire, 19th century. (Wood, textile, iron, bronze, twigs, glass and horn, 32 ½ in. × 12 in. [82.5 × 30.5 cm], THE FINE ARTS MUSEUMS OF SAN FRANCISCO, Museum purchase, gift of Mrs. Paul L. Wattis and The Fine Arts Museums Foundation, 1986.16.1.)

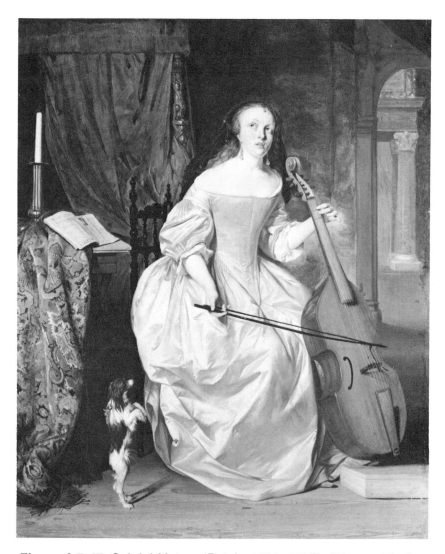

Figure 2.5 ▼ Gabriel Metsu, (Dutch, 1629–1667), *Woman Playing the Viola da Gamba,* 1663. (Oil on panel, 17 ⁵⁄₁₆ × 14 ³⁄₁₆ in., THE FINE ARTS MUSEUMS OF SAN FRANCISCO, Roscoe and Margaret Oakes Collection, 60.30.)

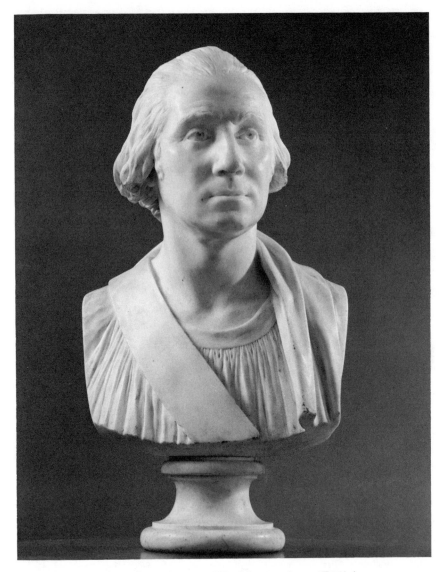

Figure 2.6 ▼ *Bust of George Washington* (ca. 1786) by Jean-Antoine Houdon. (Museum number M.76.106, Los Angeles County Museum of Art, purchased with funds given by Anna Bing Arnold.)

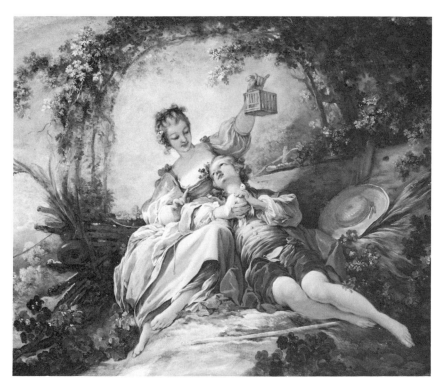

Figure 2.7 ▼ Jean-Honoré Fragonard (French, 1732–1806),
THE HAPPY LOVERS, c. 1760–65. (Oil on canvas, 35¹/₂ × 47³/₄ in.,
F.1965.1.21.P, The Norton Simon Foundation.)

cylindrical shapes, not round shapes. However, if you lean back on a bed and look at your thighs in a mirror, you will see that they do indeed then appear like round shapes. What you see on the surface of the mirror is simply more or less what the artist is reproducing on the surface of the canvas.

For another example of foreshortening, take a look at the oxen in Rosa Bonheur's *Ploughing in the Nivernais Region* **(Figure 2.8)**. Rosa Bonheur made her reputation painting animals and became a favorite artist at the court of Napoleon III. Look at the oxen nearest us, the viewers of this picture. Starting from our right, the first two pairs of oxen are shown in profile, almost as rectangular shapes. They do not look distorted. Then the third pair of oxen, just to the left of the center of the painting, appears shortened up into a square shape compared to the first two pairs. Then, at the far left, the last three pairs of oxen are painted like round shapes, with horns and legs sticking out of them. This changed appearance of the oxen, making a transition from a rectangular shape to a round shape, demonstrates foreshortening.

Usually objects appear to us smaller as they recede in space, but our eyes are not always consistent in perceiving this. That is why you will often find objects made larger as they recede in space in Greek paintings and in other paintings made before the Renaissance. Chinese and Japanese paintings also observe the same convention of making objects appear larger as they recede in space.

5. Highlighting (Modeling)

Highlighting is the use of highlights and shadows to suggest the falling of light on a solid form. Another word often used for highlighting is **modeling.**

You can see light tones running down the left side of the bowl of Magritte's pipe and along the top part of the stem, suggesting a light falling from the upper left onto a three-dimensional object. More complex examples of highlighting or modeling can be seen in the Florentine Mannerist Bronzino's painting of the Madonna with the Christ Child and baby cousin, John the Baptist **(Figure 2.9)**. Here you can see the solid forms of the limbs and torsos and heads of the babies highlighted on the left and shadowed on the right in a complex pattern of modeling that suggests not only the solidity of the forms, but also the skeletal and muscular structure underneath the skin. There are other complex patterns of modeling on the Madonna's tunic and mantle, where you can see the large shadows cast by the solid form of the infant John the Baptist in addition to the smaller shadows created by the folds of material.

How Much Realism Is Enough?

How many of these five different methods for creating realism in objects need to be used before the object appears real to you? For some people, the

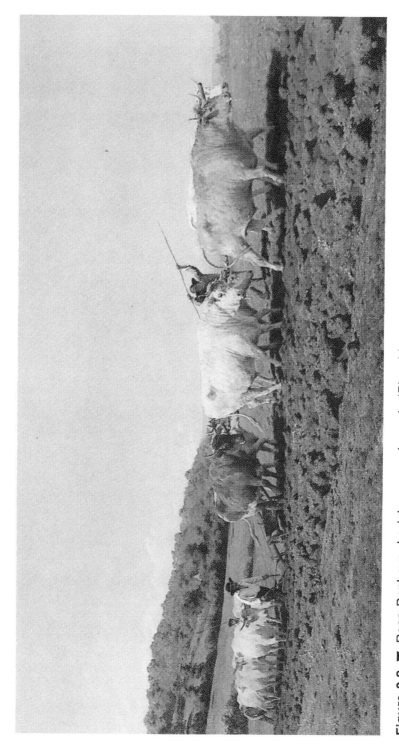

Figure 2.8 ▼ Rosa Bonheur, *Le labourage nivernais (Ploughing in the Nivernais Region)* 1849. (By kind permission of the Musée d'Orsay, Paris.)

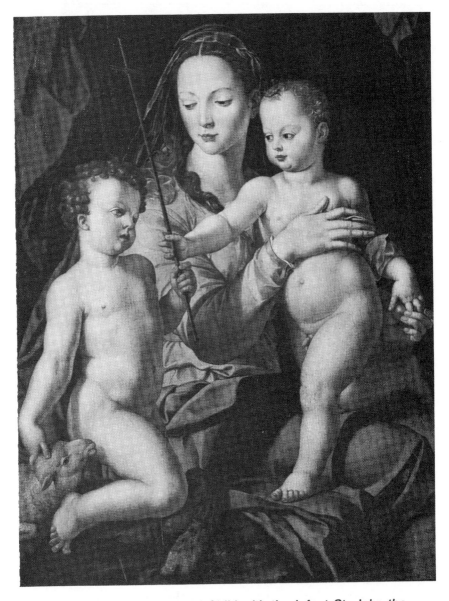

Figure 2.9 ▼ *Madonna and Child with the Infant St. John the Baptist* (16th century) by Agnolo Bronzino. (By kind permission of the Portland Art Museum.)

object appears real if just the profile and proportions are correct. For others, what makes an object real is texture, and for yet others, it is necessary in addition for the object to be foreshortened and modeled with highlights and shadows. You will find it very helpful to your future as an art critic to begin to determine where your own natural choices lie.

Meanwhile, there is another major consideration to realism that we have not discussed in this chapter. That consideration is realism in space. This subject is so complex and important for art that the whole next chapter is devoted to the methods for creating realism in space.

Notes

[1] Phenomenology is a relatively new philosophical theory of reality, beginning early in the 20th century with the work of Edmund Husserl, and continued in later interpretations by Martin Heidigger, Jean-Paul Sartre, and Maurice Merleau-Ponty.

[2] Because of the continuing influence of Plato and Aristotle, Idealism developed numerous interpretations over the centuries: Plato's version is sometimes called mystical Idealism; Bishop Berkeley's version is called subjective Idealism; Immanuel Kant called his version transcendental or critical Idealism; objective Idealism is found in three versions in Kant's successors: F. W. J. Schelling's aesthetic Idealism, J. G. Fichte's moral Idealism, and G. W. F. Hegel's dialectical Idealism.

[3] Plato, *Republic*, Book X. Abridged and adapted from the translation provided in Albert Hofstadter and Richard Kuhns, editors, *Philosophies of Art and Beauty: Selected Readings in Aesthetics from Plato to Heidegger* (New York: Modern Library, 1964), pp. 32–33.

[4] Moshe Barasch, *Theories of Art from Plato to Winkelmann* (New York: New York University Press, 1985), p. 366.

Further Reading

Barasch, Mosche. *Theories of Art from Plato to Winkelmann*. New York: New York University Press, 1985.

Gombrich, E. H. *Art and Illusion: A Study in the Psychology of Pictorial Representation*, 2nd ed., rev. New York: Pantheon Books, 1961 (Bollingen Series XXXV, 5).

Chapter 3

▼ ▼ ▼ ▼

Realism in Space

How wonderful a thing is this perspective! —*Paolo Uccello*

▼ Five Methods to Create Realism in Space
▼ 1. Overlapping ▼ 2. Register Line (Ground Line)
▼ 3. Linear Perspective ▼ 4. Aerial Perspective
▼ 5. Scientific Perspective
▼ A. Transversals ▼ B. Orthogonals ▼ C. Vanishing Point
▼ The Impact of Scientific Perspective
▼ The Challenges to Realism

The Greek revolution in realism did not stop at realism in objects, but went on to conquer space. The painting methods for realism in space in painting that were created either by the Greeks or through Greek influence in the Renaissance were unprecedented in the history of world painting, and from the Renaissance until the 20th century, creating realistic space in paintings was a major goal of art.

Five Methods to Create Realism in Space

Besides inventing three new methods to create realism in objects, Greek painters also invented two new methods for depicting space or spatial relationships in painting: linear perspective and aerial perspective. A further development of Greek linear perspective would be worked out in the Renaissance; this is the method called scientific perspective. Before the Greeks, the Egyptians used two simple methods to depict space. These were the use of overlapping objects and the use of a register or ground line. Unlike the methods to create realism in objects, these five methods to create realism in space are not generally used in sculpture. We will discuss the five methods for creating realism in space in the order of their invention in history, starting at the beginning with the use of overlapping objects.

1. Overlapping

Overlapping objects means painting one form on top of another to indicate that one form is in front of the other.

Overlapping is the simplest way to create a relationship in space, and may be found in the oldest human cave paintings and in the earliest paintings of all civilizations. You can see how overlapping creates a sense of recession into space in the arrangement of the lemons, oranges and a rose below in the still life by the Spanish painter Francisco de Zurbarán (**Figure 3.1**). On the left, two lemons overlap a third; at the center, one orange overlaps four other oranges; and on the right, a rose overlaps the lip of a saucer. You will probably have already noted that the realism of this recession into space is enhanced by the methods used to make the objects more realistically solid and three dimensional: each of the fruits and the flower is shown with foreshortening and with highlights.

The realism of Zurbarán's recession into space would have been further enhanced by increasing the number and rows of overlapping objects. For example, look at the detail of a still life of a tea set by a Swiss painter, Jean-Etienne Liotard (**Figure 3.2**). Instead of a single row of overlapping objects, there are three rows in Liotard's painting. Instead of a simple grouping of three collections of objects—the plate of lemons, the basket of oranges, and the cup and saucer with a rose—there are two rows with four collections of objects flanking a single row with three collections of objects. But the greater

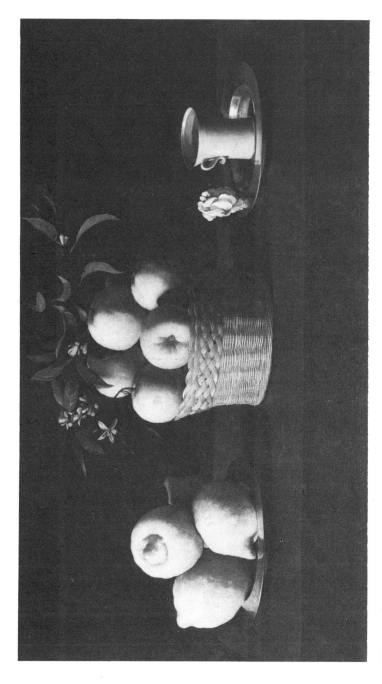

Figure 3.1 ▼ Francisco de Zurbarán (Spanish, 1598–1664), STILL LIFE WITH LEMONS, ORANGES AND A ROSE, 1633. (Oil on canvas, 24½ × 43⅛ in., The Norton Simon Foundation, F.1972.6.P.)

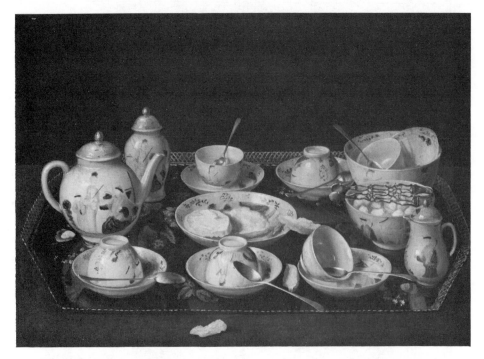

Figure 3.2 ▼ Collection of The J. Paul Getty Museum, Malibu, California. Jean-Étienne Liotard, *Still Life: Tea Set,* ca. 1781–1783. (Oil on canvas, H [left]: 14⁵/₈ in., H [right]: 14⁷/₈ in., W [top]: 20⁵/₁₆ in., W [bottom]: 20³/₁₆ in.; H [left]: 37.2 cm, H [right]: 37.8 cm, W [top]: 51.6 cm, W [bottom]: 51.3 cm.)

complexity of overlapping objects in Liotard's painting does not automatically make it more aesthetically pleasing than Zurbarán's painting. The complex overlapping of Liotard's foreshortened and highlighted cups, saucers, spoons, water pitcher, teapot, plate, fruit slices, sugar lumps, sugar tongs, tea caddy, and slops bowl make the painting's recession into space more realistic. But the bold and massive simplicity of Zurbarán's foreshortened globes of fruit makes Liotard's tea set look a trifle frail and cluttered. However, these are aesthetic distinctions that will be pursued more extensively in a later chapter.

2. Register Line (Ground Line)

A register line is a line parallel to the bottom of the picture upon which objects are located. Another term often used for register line is **ground line.**

A register or ground line anchors objects and figures in space and provides a way for creating relationships in space between two or more objects or figures. This is also an old method for creating relationships in space, although not as old as the method of overlapping objects. Register lines were not used in cave paintings, but were invented to be used for art in the world's first villages. They continued to be used by the first civilizations. You can see a register line in the example below of an Egyptian painting (**Figure 3.3**), where all the figures in the painting are shown lined up on thick black lines. If you look back to Zurbarán's painting (**Figure 3.1**), you will see that the front edge of the table functions as a kind of register line, just above which all three groupings of objects are aligned.

3. Linear Perspective

Linear perspective is the combined use of stacked register lines and foreshortened objects to create spatial relationships.

Linear perspective creates a more complex recession into space than the simple use of overlapping objects by stacking the register lines, along which several groups of foreshortened objects may have been aligned, above one other so that the objects on one line overlap those on the line above. In Egyptian painting, the objects or figures on one register line do not overlap the line above.

Greek painters invented this method of creating a recession into space. You can see how it works by looking at a Roman wall painting that reflects Greek influence in the painting from a villa near Naples that was abandoned after Mount Vesuvius erupted in 79 A.D. (**Figure 3.4**). If you examine the great doorway flanked by pilasters, you will see that the door is set on a register line a little above that of the pilasters, indicating that the door is farther back in space. The spatial recession created by stacked register lines is enhanced by highlighting: the pilasters are modeled in light, and a shadow cast by the left pilaster is painted on the stucco wall next to it. There are

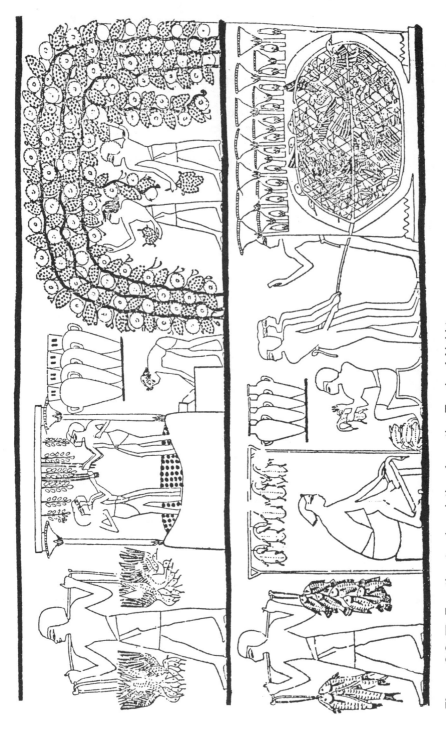

Figure 3.3 ▼ Egyptian tomb painting from the Tomb of Nakht. Reproduced from Norman de Garis Davies, *The Tomb of Nakht at Thebes*.

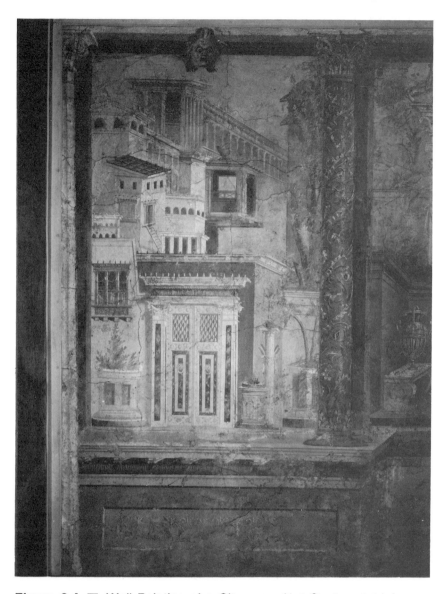

Figure 3.4 ▼ Wall Painting of a Cityscape (1st Century B.C.) from a villa at Boscoreale, Metropolitan Museum of Art, New York.

other register lines visible here: for example, the base supporting two palm trees at the right of the doorway, the base of the balcony to the left of the doorway, the base of the balcony above the same doorway on the right. On each of these lines stand foreshortened structures which overlap other structures, and thereby create their spatial relationships.

There is considerable ambiguity in the spatial relationships of this Roman wall painting, however. The base of the palm trees on the right appears to be at the same level as the great doorway at the *front* of a large rectangular building, but the *back* of the same building overlaps the top of one of the palms! Nevertheless, linear perspective provides overall a much more complex and realistic recession into space than either of the separate systems of register lines and overlapping objects that were used by painters before the Greeks.

The Greeks also invented the method of creating realism in space by means of aerial perspective. This wall painting shows an example of aerial perspective, as discussed in the next section.

4. Aerial Perspective

Aerial perspective makes objects look farther away by showing them in smaller size, with fewer details and bluer in color. Aerial perspective is sometimes called **atmospheric perspective.**

You can see that the building on a hill at the back of the city view **(Figure 3.4)** appears smaller in size and is painted with less detail than the building in the foreground: for example, the balcony seen between its columns does not show the protruding beam ends that you can see carefully painted on the balcony attached to the building in the front of the picture. Aerial or atmospheric perspective became very complex in the hands of Romantic painters in the 19th century, as you can see in the painting *Rainy Season in the Tropics* by the American Hudson River Valley School painter, Frederic Church **(Figure 3.5)**. Look at the distant mountain crag on the right, which is painted smaller and with fewer details than the crags in the front of the picture. This kind of perspective was greatly developed in the Renaissance, in particular, by the painter Leonardo da Vinci. But the kind of perspective that Renaissance painters were most concerned with was scientific perspective.

5. Scientific Perspective

Scientific perspective is a linear perspective in which the edges of foreshortened objects at right angles to the register lines in a picture are shown uniformly converging toward one or more vanishing points.

Scientific perspective provides what seems to be an extraordinarily realistic method for representing objects in space. Our eyes generally do see dis-

Figure 3.5 ▼ Frederic Edwin Church (American, 1826–1900), *Rainy Season in the Tropics*, 1866. (Oil on canvas, 561/4 in. × 841/4 in., THE FINE ARTS MUSEUMS OF SAN FRANCISCO, Mildred Anna Williams Collection, 1970.9.)

tant objects as being smaller than closer objects, and we generally do see parallel lines that stretch ahead of us as converging to a point on the horizon. Scientific perspective provides a systematic method for reproducing these perceptions. The Florentine artist Leonardo da Vinci commented on this aspect of perspective in one of his notebooks: "Perspective is nothing else than the seeing of an object behind a sheet of glass, smooth and quite transparent, on the surface of which all the things may be marked that are behind this glass." [1]

Scientific perspective is an amazing invention in another way as well, because, unlike the linear perspective that appears in Greek and Asian art, it creates a map of measurable spatial relationships. It was invented in Italy early in the 15th century in Florence by an architect, Filippo Brunelleschi, supposedly as he gazed at the reflection of the Florentine Baptistry in a mirror. Plato, who scorned both art and mirrors for imitating the world of sensory impressions, would have whirled in his grave.

Brunelleschi's painting of the Florentine Baptistry has not survived, but here is another work in scientific perspective from nearby Siena dating to a century later **(Figure 3.6)**.

This architectural view with two birds, which decorates the choir of the Cathedral in Siena, was constructed in a difficult technique of wood inlay called marquetry or intarsia. Look carefully at the tiled street leading back from the parapet on which the birds perch. Judging from the height of the doorways of the buildings, which would presumably be well over six feet in order to accommodate the easy access of a human being, we can estimate the size of the tiles to be approximately two feet square. Now look at the base of the four columns of the loggia on the left. Each one sits on and fills up an entire square, and each is separated from the other by three squares. Suppose this to be an architect's rendering and you are the mason in charge of constructing the loggia. You would be able to calculate that the base of the columns is to be two feet square, the distance between each column is six feet, and the total length of the loggia is 26 feet (2+6+2+6+2+6+2). Now look back at the Roman wall painting **(Figure 3.4)**. Could you make the same kind of calculations for the buildings in the Roman wall painting? No, because the spatial relationships are not clearly mapped out as they are in the architectural view in scientific perspective. Next, we need to look at the components of a scientific perspective: transversals, orthogonals, and vanishing point **(Figure 3.7)**. If you can learn to identify these three components, you will always be able to check for yourself whether or not a work of art was made using scientific perspective.

A. Transversals

Transversals are the stacked register lines in a scientific perspective.

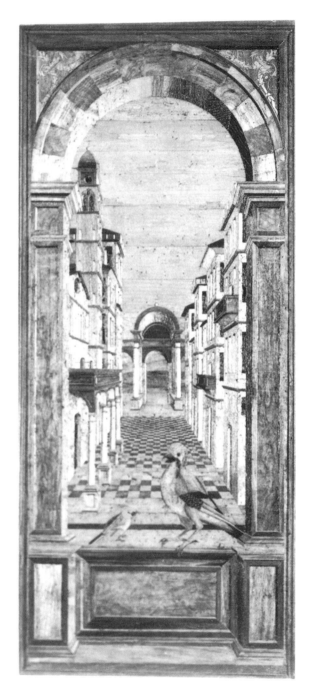

Figure 3.6 ▼ *Architectural View in Scientific Perspective* (1503) by Fra Giovanni da Verona. Wood inlay called marquetry or intarsia. (Photo by S. Gill.)

Figure 3.7 ▼ Diagram of *Architectural View in Scientific Perspective.* (Photo and diagram by S. Gill.)

You will note that the horizontal edges of the tiles provide a series of stacked register lines. The term for each of these stacked register lines in the diagram of a scientific perspective is transversal, because they "go across" the diagram. As you can observe, the spacing between transversals becomes successively smaller the higher they are stacked. This takes into account the common perception that objects seem to become smaller the farther they recede in space.

B. Orthogonals

Orthogonals are the lines along the edges of objects at right angles to the register lines that, if extended, would uniformly converge at one or more vanishing points.

The vertical edges of the tiles provide a series of lines that converge on a common vanishing point at the center just above the horizon. These lines are called orthogonals, from the Greek for "correct lines." As you can see from the diagram **(Figure 3.7),** there are other orthogonals in the architectural view than just the tile edges. The top and bottom of the loggia at the left and the tops and bottoms of the balconies at the right of the view also converge on the vanishing point. Can you find other orthogonals not marked on the diagram? In fact, since the sides of all the buildings in this view are aligned to the register lines, the elements of their facades, which are at right angles to the register lines, uniformly converge on a common vanishing point, and thus all constitute orthogonals. Objects are thus shown becoming uniformly smaller as they recede into space.

C. Vanishing Point

The vanishing point is the point at which the orthogonals of a scientific perspective converge.

The vanishing point in this scientific perspective diagram is located just above the horizon at the center of the diagram. This was the usual location for the vanishing point in early works of art using scientific perspective, but in later works, the vanishing point could be located at either side of the painting, or even outside the painting. Another development was the use of more than one vanishing point. The single vanishing point assumed a single viewpoint. But in fact our eyes are generally in motion as we view something, and using two or more vanishing points in a work of art creates a scientific perspective that appears more realistic. You can test your understanding of the vanishing point by looking at a painting that uses a vanishing point for half of its floor tiles, and not for the other half. Look at *Noel in the Kitchen* by the American painter, Joan Brown **(Figure 3.8).** Take two straight edges (rulers or sheets of paper) and line them up along the orthogo-

Figure 3.8 ▼ Joan Brown, *Noel in the Kitchen.* (Oil on canvas, 152.4 × 274.2 cm., 60 × 108 in., San Francisco Museum of Modern Art, Bequest of Dale C. Crichton.)

nals created by the tiles on the right hand side of the kitchen floor. You will see that they converge to a common vanishing point just above the top edge of the painting. Now line your straight edges up along the orthogonals of the tiles on the left side of the kitchen floor. You will find these edges do not converge to the common vanishing point of the tiles on the right side. Why did Brown paint like this? Was it because she didn't know how to construct a correct scientific perspective? Not likely. She is deliberately playing with scientific perspective to create a tension between the three-dimensionality of the tiles on the right and the flat, gestural patterns on the left. But in order to play with scientific perspective, you need to master its elements.

The Impact of Scientific Perspective

The development of scientific perspective in Renaissance Italy made a significant and lasting impact on art for two reasons.

First, it reaffirmed and reinforced the Greek goal of realism in art by providing a method for depicting objects in space that seemed so real to its first viewers that a painting could be called a "window on space."

Secondly, it provided the means for upgrading the political and economic status of art, and, by extension, of artists. In order to create the accurate map of spatial relationships in a scientific perspective, the artist was required to learn to construct a grid which was based on proportional calculations worked out by Brunelleschi and refined by later practitioners of scientific perspective. These calculations for scientific perspective provided art something it had always lacked: a theory based on proportions and numbers.

The Greeks had a mystical regard for proportions and numbers. When the Greek philosopher Pythagorus discovered in the 6th century B.C. that the intervals of a fifth, a third, and an octave in music could be demonstrably linked to measurable lengths of the strings on which they were played, his countrymen immediately raised the status of music to one of the liberal arts.

In antiquity, the seven liberal arts, which provided the traditional curriculum for the education of the powerful and rich, were divided into three language arts and four numerical arts. The language arts were grammar, rhetoric, and logic. The four numerical arts were arithmetic, geometry, astronomy, and music. You will notice that the visual arts were not included. But with the development of scientific perspective in the Renaissance, painting came to be regarded as parallel in status to music, and by the 17th century, painting was taken up as a pastime by Philip IV of Spain, and the painter Diego Velazquéz was made a courtier and a crony of the king. Painting retains this elevated status; it is the chosen pastime of Prince Charles, heir to the throne of Great Britain, as it was of his forbear, Queen Victoria.

The Challenges to Realism

All of these methods used to create realism that we have discussed in the preceding chapter and in this one continued to dominate art for hundreds of years, because the goal of art continued to be realism. In all of the history of Western art, there have been only two challenges to this goal. The first challenge came in the 5th century A.D. from the barbarian invasions of the Western world which reintroduced the goals of art that had preceded the Greeks. The second only came at the beginning of the 20th century with the introduction of Modernism.

After Plato's death in the 4th century B.C., Greek artists had continued their pursuit of realism, and passed on this goal two centuries later to their Roman conquerors who became Greek art's greatest patrons. As long as the Roman Empire was powerful, the Greek goal of realism was met in Roman paintings, mosaics, and sculptures, but when the Empire in the west weakened and fell in the 5th century before the attacks of numerous barbarian tribes whose art was not Greek, the goal of art in the lands of the old Empire changed to accommodate itself to the new tribal victors.

Greek realism was, after all, a unique phenomenon in the world. The invading tribes produced ornaments on which were shown figures in profile or frontally, as in Egyptian art, without textures, foreshortening, or modeling. The proportions in some of this art were grotesque. Occasionally overlapping forms and register lines might be used to suggest spatial relationships, but there was no linear or aerial perspective. In fact, most of the rest of the world followed these choices for non-realistic art. The Greeks were unique in history for making the choice for realism. Yet such was the attraction of their civilization, that their goal of realism in art would be revived when the west recovered from the barbarian invasions, settled into political and economic stability, and refounded the cities. And with the revival of their ideals in the 15th century in the period called the Renaissance, the Greek goal of realism was not only revived but improved with the further refinement of aerial perspective and the development of scientific perspective. When academies of art were founded in the 17th century and after, the curriculum that each established to train art students followed the same goals of realism in objects and realism in space. At the same time the academies wished to follow Plato's dictate that the particular was inferior to his Ideal. To get around this contradiction, the academies chose as objects for their drawing classes the most idealized objects they could locate: plaster casts of Greek statues, whose features were seen as idealized, not particular. To achieve realism in space, most academies required students to take one whole year of training in scientific perspective.

The second challenge to the Greek goal of realism began at the end of the 19th century with the Post-Impressionists and steamed into the 20th century with the development of the art movement called Modernism. Modernism as a movement essentially means abstract art—art whose goal is not

realism. The traditional goal of realism and all the methods used to achieve realism in objects and realism in space that had been so painstakingly taught in the academies were suddenly thrown out the window by artists. Or if they were not thrown out the window, then they were playfully mocked.

You can imagine the bewilderment, frustration, and rage of art critics, who found that their traditional approach of realism was not adequate for the new works of art being produced and exhibited. People kept desperately looking for something familiar to cling to in the new works, even imagining realistic objects where there were none. Finally, a new way to approach art developed out of the necessity to discuss the new art in some other terms than realism. The new approach talked about the arrangement and quality of forms in art. This approach is called formalism, and we will explain its methods in the next chapter.

Notes

[1]Quoted by James Beck, *Leonardo's Rules of Painting* (New York: Viking Press, 1979), p. 93.

Further Reading

Cole, Rex V. *Perspective: The Practice and Theory of Perspective as Applied to Pictures*. New York: Dover Publications, 1927.

White, John. *The Birth and Rebirth of Pictorial Space*. London: Faber and Faber, 1957.

Chapter 4

▼ ▼ ▼ ▼

Formalism as a
Universal Approach

Before a work of art people who feel little or no emotion for pure form find themselves at a loss. They are deaf men at a concert. —Clive Bell

Origins of Formalism

Formalism as an approach to art began in England in the early 20th century with the writings of Roger Fry and Clive Bell. Roger Fry (1866–1934), editor of the influential *Burlington Magazine* in England, began by studying painting in Italy, and later acted as European advisor to the Metropolitan Museum in New York. Fry became a champion of the work of Cézanne, Van Gogh, Gauguin, and Matisse among others, and organized a major exhibit of these artists in London in 1910. The term "Post-Impressionists" that Fry coined for this exhibit was soon expanded by other critics to mean all avant-garde artists in this period, although 30 years later, the term would be restricted to Cézanne, Van Gogh, and Gauguin. Fry's articles and books on these artists, and his later books on art theory, moved away from considerations of realism, and concentrated on what he called "plastic and spatial relations" in art, by which he meant the relationships of objects and space. Fry's major contributions to formalism were to discount realism as an approach to these early moderns, and through painstaking analysis, to separate out considerations of form from the expressionistic aspects in a work of art.

Nearly a generation younger than Fry, Clive Bell (1881–1964) studied art in Paris and London, and turned to art criticism after his marriage to Vanessa Stephen in 1907 put him at the center of the Bloomsbury group of artists and writers in London. The Bloomsbury group was led by Bell's sister-in-law, the novelist Virginia Woolf, and her husband, Leonard Woolf, who owned the Hogarth Press. Bell first met Roger Fry on the train between Cambridge and London in 1910, beginning a lifelong association based on their common interest in art. Together they organized a second Post-Impressionist exhibit in London in 1912. Bell's writings on art were deeply influenced by Fry, but Bell contributed the term "significant form," by which he meant lines, colors, and space in "arrangements and combinations that move us aesthetically." From this term, the approach came to be known as "formalism."

Formalism proved to be more adequate than the approach of realism to an understanding of the abstract art flooding Europe and the United States at that time. Modernism, as the movement of abstractionism in art is called, was then at high tide with one version rapidly following another, Fauvism, Cubism, Purism, Orphism, Futurism, Suprematism, ending at last in the United States in the 1950's with Abstract Expressionism. Most critics discussing abstract works began to use formalism as an approach, usually in opposition to the approach of realism. For example, the American critic, Clement Greenberg (1909–), who trained at the Art Students League in New York and went on to become an editor and influential art critic, noted in 1954 that: "The presence or absence of a recognizable image has no more to do with value in painting or sculpture than the presence or absence of a libretto has to do with value in music."[1] For Greenberg, the aesthetic value of a work of art was to be found not in what it represented, but in its forms.

Formalism as a Universal Approach

The formalist approach supplied a new way to analyze abstract art that the approach of realism was unable to provide. And because, outside of the Greek tradition of realism, most of the world's art was not realistic, the new formalist approach suddenly opened Western eyes to a new appreciation of the abstract forms of African fetish figures, Native American artifacts, and much Asian art. The realistic forms of Greek-influenced art may also be appreciated through formalism. Because it can be used to evaluate art from any place or period, formalism is a truly universal approach. It is universal in another way as well, we believe, because what it analyzes are universally appreciated aspects of art, evoking the same kind of aesthetic response in all human beings.

Aesthetic Response Based on Universal Experiences

While united in believing that the forms of art evoke an aesthetic response, the advocates of the formalist approach never provided a satisfactory explanation of the causes of the aesthetic response. Most art critics of this period and earlier were content to describe their own aesthetic response to art simply as "ecstasy." The American connoisseur, Bernard Berenson, who said that art should "tune us like instruments—instruments of ecstasy," was probably influenced by the passionate Victorian critic, Walter Pater, who did not wish to analyze his aesthetic response but only to prolong it: "to burn always with this hard gem-like flame, to maintain this ecstasy, is success in life." The Modernist critic, Roger Bell, at one point even suggested that what he really meant by significant form was the Platonic Idea, when he said that significant form "was form behind which we catch a sense of ultimate reality," and reality is "that which lies behind the appearance of all things." [2]

As a possible explanation of why the forms of art evoke an aesthetic response, we would like to suggest that the way in which each of us responds to the forms of a work of art is founded in our own sensory and psychological experiences. We believe that our aesthetic response to the forms is unique to us as individuals, yet similar to others in that we all share the same basic human sensory and psychological equipment. Whether we grow up in Africa, the Americas, or Asia, we are all capable of feeling the same aesthetic response to the same forms of art. Presumably, if you were to choose two different works of art, one better than the other in regards to the quality and arrangement of forms, and went flying around the world with them, asking people in all kinds of nations and tribes to say which was better, you would, after you discounted answers based on the approaches of realism or expressionism, get a consensus that agreed with your choice. [3] In that sense, then, the language of forms that evokes this response is universal.

A Special Aesthetic "Attitude" Not Needed

There are some aestheticians who believe that looking at art requires a special attitude that is completely different from the usual way of looking at the world. We do not believe that you need a special attitude. What you do need to do is simply to focus on the work of art. You need to pay sharp attention with your mind as well as with your eyes to all of its different forms. The more you look at and consider a work of art with your full attention, the more you will be able to find in it. The discussions of the different forms of art in the following chapters will help you focus on more aspects of a work of art, and will increase your aesthetic response to the work. As a dividend, you will find that your increased aesthetic response to art will enhance your response to the forms of nature or your urban environment. The more that you really look at and respond to works of art, the more you will be able to locate and respond to dynamic compositions, complex rhythms of repeated shapes, sensuous textural contrasts, powerful images, sweeping spaces, and rich colors all around you that you never noticed before. You will begin to walk in beauty every day.

How the Forms of Art Evoke an Aesthetic Response

The aesthetic response to the forms of a work of art appears to us to be very complex, deriving in part from the evoked memory of previous sensory experiences, in part from actual sensory experiences, and in part from human psychological needs. We will examine how the forms of art stimulate an aesthetic response by discussing in detail their arrangement and quality with reference to our sensory and psychological experiences. As much as possible, we will use examples of abstract art, so that you can see how the formalist approach works with this kind of art. We will also use a few examples of realistic art to show you that the formalist approach can be used with these as well.

The Forms of Art

Forms refer to the arrangement and quality of the forms or shapes of a work of art.

The *arrangement* of the shapes means their *composition, balance, and rhythms*.

The *quality* of the shapes means the handling of their *line, texture, mass, space, light, and color*.

Of these nine aspects of form, composition and balance evoke or call upon our previous experiences of *gravity*, and rhythms refer to our *psychological need for order*. These will be discussed in this chapter.

The handling of line, texture, and mass evoke or call upon our *previous tactile experiences,* and the handling of space and light evoke our *previous visual experiences.* The handling of color, alone of all the aspects of form, creates an *immediate visual experience.* The forms referring to visual experiences will be discussed separately in the next chapter.

To help you in your study of the arrangement and quality of the forms of a work of art, each discussion of these aspects of art will be accompanied by questions designed to aid you in focusing on the work.

Composition

Composition means the arrangement of forms in a work of art to appear stable or dynamic.

Both composition and balance in the arrangement of forms in a work of art refer to your previous sensory experiences with gravity and motion. While we as individuals have our own particular experiences with gravity, all human beings brought up on Planet Earth have had similar experiences of the constant pull of this large, dense body of matter upon our frailer bodies. We have special sense organs within our inner ears to tell us when our bodies go out of balance. We have other special sense organs located in our muscles, tendons, and joints that perceive the tension, motion, and position of our limbs. Our sensory memories of these experiences are evoked as part of our aesthetic response when we look at the composition and balance of a work of art.

Stable Composition

Horizontal and vertical forms appear stable. When you look at a composition or arrangement of forms, such as the metal piece called *Solea* by the Californian sculptor Peter Voulkos **(Figure 4.1),** that you may instinctively feel is *stable or peaceful,* your aesthetic response is based on your *previous sensory memories of gravity and motion.* You know from your own experiences of gravity that you feel stable when your body is lying aligned horizontally to the earth's surface, or when it is completely upright and not leaning off-balance one way or the other. You can feel in your body whether or not your muscles, tendons, and joints are relaxed or tensed against the pull of gravity. If you look carefully at the forms or shapes of *Solea,* you will notice that it is made up of a thick, horizontally aligned metal slab supported by four tall, sturdy vertical elements. These are the elements that are evoking an aesthetic response from you of the feeling of stability.

Dynamic Composition

Curved and diagonal forms appear dynamic. When you look at the two segments of spheres perched on top of the metal slab of Voulkos's sculpture, you

Figure 4.1 ▼ Peter Voulkos, *Solea,* 1968. (Monel, bronze and copper nickel, 10 × 6 ½ × 4 ft., Long Beach Museum of Art, gift of the Museum Association.)

may instinctively feel these forms are in tension or potentially in motion. You may almost feel that the larger segment of sphere could roll right off the top of the flat slab if it weren't blocked by the flat side of the other segment. Forms that appear in tension or potentially in motion are said to be *dynamic*. Your aesthetic response to these forms is based on your body's experience of tension or motion as you get up from a horizontal position or lean out of a vertical position.

Now take a look at the composition of an abstract painting, *Elegy to the Spanish Republic No. 160* (**Figure 4.2**). This is one in a long series of works by the Abstract Expressionist painter, Robert Motherwell, grieving the overthrow of the liberal Republican government in the Spanish Civil War. Can you identify which forms are stable and which ones are dynamic? When you are analyzing abstract art, you will find it helpful to come up with some kind of a label for each of the forms you want to discuss. Here in Motherwell's painting, for example, you may want to refer to the four "oval shapes" or the black, grey, or white "rectangular shapes" or the "vertical lines" or "horizontal lines." You may have already identified the rectangular shapes, the vertical lines, and the horizontal lines as being stable forms, and the four oval shapes as being dynamic forms. Now try to decide which group of forms dominates. In other words, is this composition as a whole mostly stable or mostly dynamic? Step back and look at the forms from a distance in order to be able to see the effect of the composition as a whole. You will probably see the oval shapes creating a thick horizontal row, supported by two sturdy vertical rectangles, not unlike the basic composition of Voulkos's sculpture. If you decided that the composition of the painting was predominantly stable, you would be correct.

There is no right or wrong between stable and dynamic compositions. Dynamic compositions may be just as aesthetically pleasing as stable ones, or as compositions which use an equal number of stable and dynamic forms. The comfortable calm and peace we feel looking at a stable composition is not aesthetically better than the exhilarating tension we feel looking at a dynamic composition. To use an analogy from music, one key is not better than another; the particular combinations of sharps and flats in different keys simply stimulate different aesthetic responses.

Questions on Composition

When you are looking at the composition of a work of art, you will find it helpful to ask yourself:

a. Is the composition stable? This refers to your previous experiences of gravity. A composition is stable when it has many horizontal or vertical forms.

b. Is the composition dynamic? A composition is dynamic when it has many diagonal or curving forms.

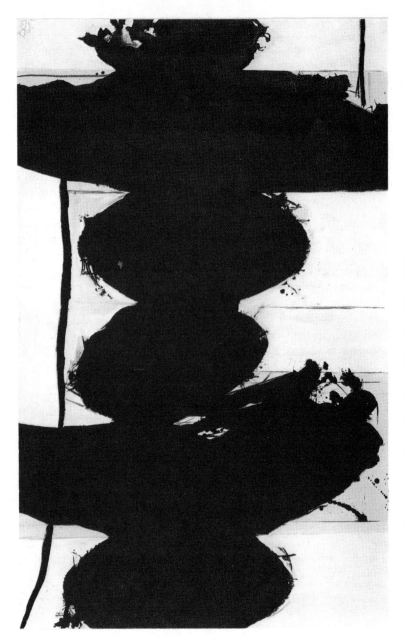

Figure 4.2 ▼ *Elegy to the Spanish Republic No. 160*, 1979, by Robert Motherwell. (By kind permission of the Hess Collection, Napa.)

Balance

Balance means the arrangement of forms in a composition so that one half seems to weigh the same as the other.

Like your response to the stable or dynamic aspects of composition, your aesthetic response to the aspect of balance in a work of art is based on your previous experiences of gravity. When we look at the forms of a work of art, we instinctively feel more comfortable if the forms are in balance. We all know in our bodies how uncomfortable and stressful it is to walk around carrying a heavy object on one side only.

Look once again at the sculpture *Solea* by Voulkos **(Figure 4.1)** to see if the forms are balanced. You will find it helpful to visualize an imaginary divider running vertically through the center of the work dividing it in half. Does one half appear substantially heavier or lighter than the other? In the case of this sculpture, the forms appear to be balanced. An imaginary vertical divider cutting the forms in half would produce two similar shapes. Now look at the *Mazarin Venus,* a Roman copy of a Greek statue of the goddess of love once owned by Cardinal Mazarin in France **(Figure 4.3)**. Try mentally dividing this figure of a woman, drapery and a dolphin into two vertical halves. You will see that this sculpture is also balanced, the fat dolphin at the lower right balancing out in size and weight the drapery carried up to the upper left.

Balance and Symmetry

We say that a work of art is *symmetrical* when both sides are similar in size and shape, as well as weight. Symmetry generally refers to the two sides, and not to the top and bottom of a shape. It is possible to have top-to-bottom symmetry instead of side-to-side symmetry, but this would be an unusual composition for a work of art. You will find that symmetry in a work of art generally runs side-to-side.

When both sides are not alike, but nevertheless appear to be weighted the same, we simply say the work is *balanced.* The size of the forms is the usual determining factor for balance, but in paintings the use of dark and light tones may also be a factor. For unknown reasons, dark tones usually appear heavier than light tones.

Examine Motherwell's painting again **(Figure 4.2)**. Are the forms symmetrical, or simply balanced? The rectangle and two ovals on the left are nearly the same size and shape as the rectangle and two ovals on the right. The rectangle on the left is angled slightly towards the center at the bottom and is open in appearance at the bottom, making it feel lighter in weight than the more solid bottom of the rectangle on the right. But the rectangle on the left is given a little extra weight by the placement of a grey rectangle behind it. The end effect is one of symmetry and equal weight. The forms appear not just balanced, but symmetrical.

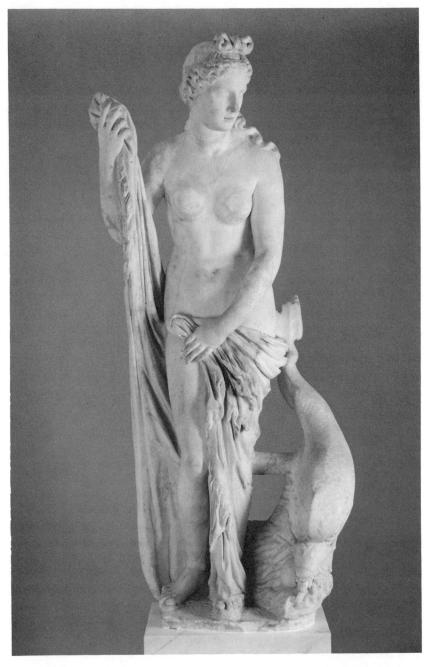

Figure 4.3 ▼ Collection of The J. Paul Getty Museum, Malibu, California. *Mazarin Venus.* Roman copy after Hellenistic original. (Pentelic marble for original; Carrara marble for restoration.)

Question on Balance

Here is a useful question to ask concerning the balance of shapes when you are looking at a work of art:

Are the shapes in the composition of your work of art balanced? That is, do the sizes and weights of shapes on each side of the composition seem about equal? The quality of balance is based on your previous experience with gravity.

Variety in Unity and Unity in Variety

You may have observed that the ovals and rectangles on the left in Motherwell's painting are similar but not identical to the ones on the right. In the Voulkos sculpture, the segments of spheres on top of the slab are not identical in shape and size. These irregularities introduce a variety within the balanced order of the forms. Most works of art with balanced arrangements seem to contain this variety in sizes and shapes of forms. This human preference for variety over exact symmetry has been identified by aestheticians as the basic art design principle of "variety in unity" or "unity in variety." [4] You will find a similar choice of variety in unity in the rhythms of repeated shapes in a work of art.

Asymmetry

When one half appears heavier or lighter than the other, we say that the forms are *asymmetrical* or unbalanced. But as with the stable and dynamic aspects of composition, a balanced composition is not better than an asymmetrical one, just more usual. Asymmetrical arrangements, like dynamic forms, make us feel tense.

Rhythms

Rhythms are the orderly repetitions of similar forms in a work of art.

Unlike the responses to composition and balance, our aesthetic response to the rhythms of repeated forms in a work of art appears to be based on a human need for order, rather than on a previous sensory experience. We believe that the need for order is fundamental to human psychology, and that order is basic to human art. This psychological need may be a human response to the perceived chaos of reality, one that sets up predictable systems as an antidote to the random misfortunes of life. One important means of creating order in a work of art is the rhythmic repetition of a form. Rhythms seem to be as basic to a work of art as they are to music and dance. But the rhythms of a work of art are not as easy to identify as music and

dance rhythms. Works of art don't have scores that are helpfully labeled 2/4 or 3/4 time.

Locating Rhythms

You will be able to locate and identify the rhythms of a work of art by care-fully examining its forms. As you learned in the discussion of composition, you will find it helpful to think of a label for each of the forms as you are looking. Begin with a large and obvious form, give it a name, and then look for other forms that resemble it. One abstract work of art with complex rhythms of repeated forms is *Open Green* by the Russian Expressionist painter, Wassily Kandinsky **(back cover).** Examine this painting carefully to find a large, obvious form. There are two big white forms that you could begin with: either the large white circular shape on the lower right of the painting, or the tall rectangular band of white at the left of the painting. But say you begin with the large white circle. You will need to label it. You may want to call it "circle" or "large white circle." Or you may want to call it "translucent disc" or "translucent sphere." Each part of these labels repre-sents a particular aspect of the form that you have observed. At this stage of analysis, it is better to choose a label that is simply descriptive of the form and does not express much meaning. Calling this circle an "Unidentified Fly-ing Object" or a "Snowball from Hell" will block you from seeing the form's resemblance to other forms. For the sake of simplicity, we will assume that you have labeled this form "circle."

Now look for other forms that resemble your circle.

You will probably be able to locate a black edged circle in the top cen-ter of the painting, bisected with a black line and divided again by a peach and violet triangle. Above this circle is another black edged circle, divided into red and yellow halves. Two half circles riding on straight lines, one half circle edged in black, the other painted all in white, are placed at the top and the far left of the painting. Four other smaller black edged circles are located at the top left of the painting. There is a large quarter circle of pink and white floating at the top left corner of the picture. There are patterns of grey dots partly edged with black that flank the first circle you located, and a kind of three-quarter circle edged in yellow above the wavy lines to the left of the painting.

Did it surprise you to find so many other circles or partly circular shapes? You have discovered one of the rhythms of repeated shapes in Kand-insky's painting. Examine the distribution of these circles. You will find that apart from the clusters of dots, they are mostly distributed along a curving S-shaped path running from the lower right to the upper left of the painting.

Now find a label for the white rectangle and search for other rectangu-lar shapes that resemble it. You may want to call it "rectangle." You will notice that the white rectangle you are beginning with has two rectangles in

blue and pink sitting on top of it. These two colored rectangles form a square. While you are looking for rectangular shapes, you may also want to look for square shapes. You will probably first see the large black and white rectangular stripes running at an angle to the original white rectangle, with their sides converging as if they were receding in space. At an angle to them are shorter black and white rectangular stripes. Above, at an angle to the white rectangle and the pink and blue square on top of it, runs a pattern of colored squares with converging sides, like a checkerboard receding in space. So here we have an interesting parallel of linked shapes: a white rectangle with receding black and white stripes, parallel to the shape of a colored square with receding colored squares. And these patterns of rectangles and squares are linked by the curving path of circles: the large white circle over-lapping the short black and white bars also hovers over the receding stripes of black and white, as the black edged circle hovers over the checkerboard, and the other circles describe a path that curves over the pink and blue square and the original white rectangle.

Would you like to continue to find these rhythms of repeated shapes? There are more in this complex painting. Look for: triangles, wavy lines, arcs, and double-peaked shapes rather like a distant mountain range. There are even some repeated pentagon shapes.

You may have noticed that none of these repeating forms is exactly identical to another. We believe there is probably a reason in human psychology for this too. While we as humans crave the predictable order of rhythms in art, once we have achieved it, we then seem to want to spice it up with a little variety.

Variety Preferred Over Predictability

We believe that predictability and variety represent two poles of aesthetic choice when it comes to the rhythms of repeated forms. **Predictability** *means that the forms which are repeated are almost identical.* **Variety** *means that the forms which are repeated are somewhat similar, but not identical.* As you become accustomed to locating the rhythms of repeated forms in works of art, we believe that you will come to prefer works with more varied rhythms over works with simple, predictable rhythms. Suppose Motherwell's *Elegy to the Spanish Republic*, instead of varying the clusters of two ovals framing a rectangle, had exactly duplicated one of them, as we show in our modified version of the painting in **Figure 4.4.** Compare the real painting with the modified version. Which of the rhythms do you prefer? We think that you will prefer Motherwell's rhythms to the simplified rhythms of the computer modified version. Or suppose Kandinsky's painting to be made up of exactly repeating circles, rectangles, and squares, as shown in our modified version in **Figure 4.5.** The patterns seem very rigid and uninteresting compared to the complex rhythms in the real work by Kandinsky.

Figure 4.4 ▼ Computer Modified Version of Motherwell's *Elegy to the Spanish Republic No. 160.* (Version by S. Gill.)

Figure 4.5 ▼ Computer Modified Version of Kandinsky's *Open Green.* (Version by S. Gill.)

For a masterpiece of variety in rhythms in a work of art, look at Picasso's *Les Demoiselles d'Avignon* **(Figure 4.6)**. The five large forms in the painting, based on the figures of women in a bordello, are each surprisingly different, and do not exactly repeat each other. Picasso employs a rhythm of repeated triangular shapes throughout every form in the painting, but again, not one is identical with another.

Locating Rhythms in a Realistic Work

The approach of formalism may also be used for a realistic work of art. If we examine *El Dia de Los Flores, Xochimilco (Day of the Flowers, Xochimilco)* by the Mexican artist Diego Rivera **(Figure 4.7)**, we will find numerous rhythms of repeated shapes that give this painting a sense of deliberate order. Look at this just as you would an abstract work. Look for a large, obvious form and give it a name. For example, the large oval face wearing a wreath at the lower left corner of the painting. Call it an oval face. Do you see any other oval faces? If you look, you will see five other oval faces, shown frontally. You will also see six other oval faces shown in profile or in three-quarter view. There are other rhythms of oval or partly oval shapes in the flower garlands framing the two large faces on the left, in the wreath of flowers held by a woman on the right and in the wreath hanging from a tree behind her, in the braided hair of the young girl in the right corner, and in the rim of the hat worn by the man poling a boat. Now look for other repeated shapes. You may find these: the faceted oblongs of the flowers of the wreaths, the circular shapes of the flowers in the foreground and dotting the garlands above the boat, the squared shapes of the flowers being handed to a bending man by one of the women, the vertical shapes of the five trees, the triangular shapes of roofs, the wavy lines of water, the curved swags of garlands echoing the curves of the outstretched arms of the women below.

How the Need for Order Sometimes Imagines Order Where None Exists (Gestalt Psychology)

You have seen over and over again how the human need for order manifests itself in art by creating rhythmically repeating shapes. In fact, the human need for order appears to be so great that the brain will sometimes imagine it sees order where none exists in reality. This is the basis for the laws of gestalt psychology. ("Gestalt" is the German word for "form" or "pattern.") These laws take note of the different ways our brains impose order: by imagining forms that will continue the direction of existing forms (law of continuity); by imagining groups of forms where randomly associated forms exist, either close together or of similar shapes (laws of proximity and similarity); and by imagining complete patterns where incomplete patterns exist (law of closure). Gestalt psychologists have also observed another way the brain looks

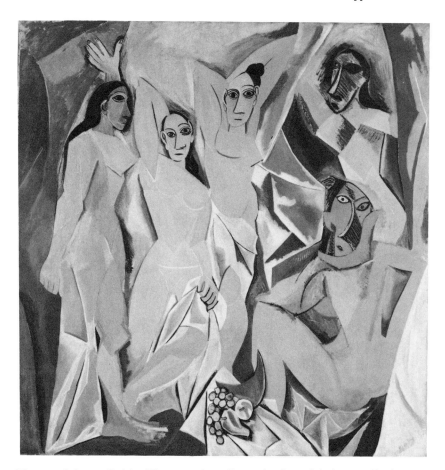

Figure 4.6 ▼ Pablo Picasso. *Les Demoiselles d'Avignon.* Paris (begun May, reworked July 1907). (Oil on canvas, 8 ft. × 7 ft. 8 in. Collection, The Museum of Modern Art, New York. Acquired through the Lillie P. Bliss Bequest.)

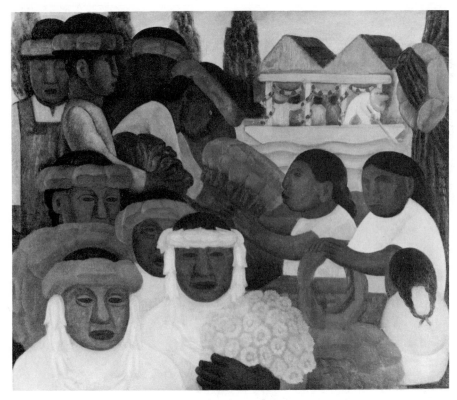

Figure 4.7 ▼ *El Dia de Los Flores, Xochimilco,* 1926, by Diego Rivera. (By kind permission of the Fresno Art Museum.)

for order: by focusing attention on a *figure* (the object focused on) and ignoring its existing *ground* (background). It should be noted that not all the patterns that the brain sees are imaginary. There really are patterns and rhythms out there in reality, and sometimes the brain grasps these before our sensory receptors have provided all the data. But occasionally too the brain is fooled, and the sensory data do not back up what the brain imagines it saw. For this reason, we have chosen to focus on sensory perception as our approach to art. However, pattern recognition is very important in the human processing of visual perception, and those interested in the application of the laws of gestalt psychology to art should pursue this subject in the excellent writings of Rudolf Arnheim, in particular, his *Art and Visual Perception: A Psychology of the Creative Eye—The New Version* (1974).

Questions on Rhythms and Variety

Here are questions to ask yourself as you begin to train your eye to find the ways that order is created in your chosen work of art through the use of rhythms of repeated shapes.

a. Do you see a single shape that is repeated? It may be a simple shape, like a curved line, or a complex shape, like a hand or body. Remember, repeated shapes make rhythms that are pleasing to us as humans. All humans like rhythms because rhythms of repeated shapes create the order that we crave.

b. Are you finding that the repeated shapes are not exact duplicates? Variety contributes to the quality of a work of art.

Once you begin to focus on the rhythms of repeated shapes in art, you will find them in astonishing profusion, and we predict that you will soon learn to delight in their variety. The profusion and variety of rhythms in art are, we believe, a visual monument to the amazingly inventive powers of humanity.

But there is yet more to be valued in the forms of a work of art than the composition, balance, and rhythms that we have focused on in this chapter. In the next chapter, we will examine the handling of line, texture, mass, space, light, and color.

Notes

[1]Clement Greenberg, "Abstract, Representational, and So Forth," in his *Art and Culture* (Boston: Beacon, 1961), p. 133.

[2]Clive Bell, *Art* (Oxford: Oxford University Press, 1987), p. 54, p. 69.

[3]There is one recorded experiment of this sort in which photographs of African BaKwele masks that had been evaluated by art school students in

New Haven were then evaluated in Africa by a group of BaKwele mask makers and experts. The choices of the two groups showed "significant agreement" which the authors thought was consistent "with the notion that the aesthetic appeal of a work of art to an art-involved viewer is partly a function of universals of human nature." Irvin L. Child and Leon Siroto, "BaKwele and American Aesthetic Evaluations Compared," in *Art and Aesthetics in Primitive Societies,* edited by Carol F. Jopling (New York: Dutton, 1971), pp. 271–289.

[4]For example, see Stephen C. Pepper, "Aesthetic Design," in John Hospers, ed. *Introductory Readings in Aesthetics* (New York: Free Press, 1969), p. 69.

Further Reading

Arnheim, Rudolf. *Art and Visual Perception: A Psychology of the Creative Eye—The New Version.* Berkeley: University of California Press, 1974.

Battcock, Gregory, ed. *The New Art.* New York: Dutton, 1973.

Bell, Clive. *Art,* edited by J.B. Bullen. Oxford: Oxford University Press, 1987.

Fry, Roger. *Vision and Design,* edited by J. B. Bullen. Oxford: Oxford University Press, 1981.

Greenberg, Clement. *Art and Culture.* Boston: Beacon, 1961.

Chapter 5

▼ ▼ ▼ ▼

The Sensory Experiences of Formalism

Art is a matter strictly of experience, not of principles, and what counts first and last in art is quality. —Clement Greenberg

The Sensory Experiences of Formalism

The "form" in formalism refers to the arrangement and quality of the forms or shapes of a work of art. As we discussed in the last chapter, the *arrangement of the forms* refers to their composition, balance, and rhythms. You discovered that the composition and balance in a work of art evoke your previous sensory experiences of gravity and motion, and that the rhythms of repeated forms in a work of art refer to your human need for order.

The *quality of the forms* in a work of art means the handling of line, texture, mass, space, light, and color. As we shall see, these aspects of form in art are based on different sensory experiences, in particular, on our senses of touch and sight. The quality of any form in a work of art depends upon the degree and intensity of the sensory experience. In order to help you analyze the quality of the forms in a work of art, you will find questions at the end of every section on the particular sensory experiences.

Tactile Experiences

Our sensory experiences of touch are called tactile experiences.

The handling of line, texture, and mass evoke our *previous tactile experiences*. Our tactile experiences come to us through a vast number of sensory receptors embedded in the single largest sense organ of our bodies, that is, the skin. The skin contains a variety of receptors that respond to different kinds of touch stimulus: pain, gentle pressure, heavy pressure, cold, and heat. The number of receptors in the skin is greatest for pain, followed by the numbers for gentle and heavy pressure. The skin's receptors will adapt to a steadily applied stimulus of pressure or temperature, and will cease to respond unless the stimulus is varied. For example, the body will adapt to a steady condition of heat or cold within a wide range, and will cease to respond to it by shivering or sweating profusely if the temperature remains constant. This is true no matter whether the temperature is at a constant 65 degrees or at a constant 100 degrees. As for steady tactile experiences, you may have noticed that you are not usually aware of the pressure of your clothing on your skin, until you move around and change the pressure. This dulling of the senses to an unchanging stimulus may be a reason why we as humans seek variety in works of art. We may be seeking a renewal of sensory stimulus.[1]

The experiences of pressure, rather than pain or temperature, are the kinds of tactile experience that are evoked by a work of art. The tactile experiences evoked by a work of art have to do with the way we as humans use touch to learn about an object in the real world. We feel its edges by running our hands around it, and we stroke its surfaces or brush up against it. These are the experiences that are evoked in a work of art by the handling of line, texture, and mass.

Line

Line, in a work of art, means a shape like a thread or band.

The use of line in a work of art to define the edges of forms is one way in which our previous tactile experiences are evoked.

Line as Edge

We all know what it is like to run our hands around the edges of an object and feel its contours. It is this tactile experience that is evoked by a work of art which uses line rather than light to define the edges of forms. The Mexican surrealist painter Frida Kahlo uses line in this way in the painting she did of herself and her husband, *Frieda and Diego Rivera* for their host on the occasion of their visit to San Francisco in 1931 **(Figure 5.1).** If you look at their joined hands, you will see that the edges are defined by lines. The right edges of Frida Kahlo's face, neck, and shawl are defined by lines. The pocket, collar, and button placket of Diego Rivera's shirt and his paintbrushes are defined by lines. These lines which define edges simulate the shape we would feel if the painted figures were real and we could run our fingers along their edges. We can imagine this sensation from previous experiences of running our hands around objects, and this previous experience is evoked by the lines defining edges in Frida Kahlo's painting. The lines do not simulate what our eyes would see. In reality, forms do not normally appear with lines around them.

Line as Rhythm

Of course, line may be used in other ways in art than to define edges.[2] Lines may be used in art to create rhythms of repeated shapes; for example, the embroidered pattern on Frida Kahlo's shawl, or the whiskery black arcs you have seen previously in Kandinsky's *Open Green* **(back cover).** In this use, the lines are forms that refer to the human need for order.

Line as Shading

Lines may be used to create areas of shading through the means of cross-hatched or parallel lines. This use, which refers to your previous sensory experience of light, will be considered later in this chapter in the discussion of light. Lines may also be used very abstractly in diagrams, and in this usage generally do not evoke any sensory experiences. Lines used in diagrams are there primarily to convey meaning, and not to please us aesthetically through their quality and arrangement. This doesn't mean that diagrams can't be aesthetically pleasing, only that the meaning is primary and any aesthetic consideration will be secondary. Lines may be used to convey meaning in

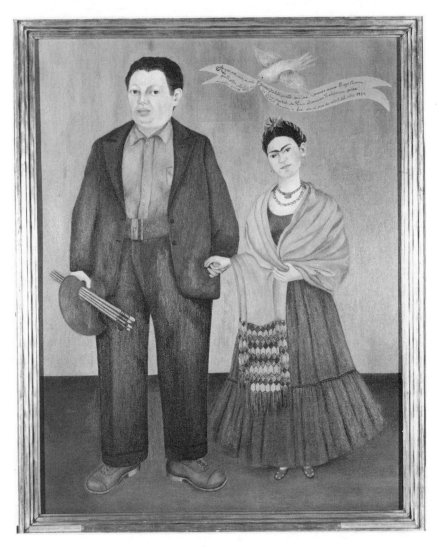

Figure 5.1 ▼ Frida (Frieda) Kahlo, *Frieda and Diego Rivera*, 1931. (Oil on canvas, 100.0 × 78.7 cm., 39 ⅜ × 31 in., San Francisco Museum of Modern Art, Albert M. Bender Collection, Gift of Albert M. Bender.)

another way. The "gestural line" that was the foundation of Abstract Expressionism is a line that is both diagrammatic and expressive.

Gestural lines, from the word "gesture" which means "expressive movement," are lines that sketch forms and suggest meaning at the same time. Depending on the specific way in which the gestural line is used to sketch form, it may be aesthetically pleasing as well as expressive of meaning. For example, the gestural lines formed by thick brushstrokes and dribbled paint in the abstract work seen in **Figure 5.2** create rich patterns of repeated shapes that are aesthetically pleasing. Painted by Arshile Gorky, who came to the United States from Armenia at the age of 16, the work's patterns have something of the quality of the abstract linear patterns of folk embroidery, as expressed in the title provided by the artist: *How My Mother's Embroidered Apron Unfolds In My Life*. The thick black brush strokes of Motherwell's *Elegy to the Spanish Republic, No. 160* **(Figure 4.2)** may be seen as gestural lines. These thick lines, whose rhythms of repeated shapes were discussed in the last chapter, also express an emotional meaning. The starkness of the black against the white, the mournful lack of color, conveys a sense of Motherwell's profound reaction to the defeat of the Spanish Republic by fascists. But we will discuss expression in art in the next chapter.

Questions on the Use of Line

When you are trying to analyze the particular quality of line in a work of art, you will find these questions helpful to ask yourself about the work:

a. Is line used to define the edges of objects? This use of line evokes previous tactile experiences.

b. Is line used to create linear patterns or rhythms? This use of line helps create the order that is a part of every work of art.

c. Is line used to create areas of shading? This is a use of line that may add either to the quality of texture or to the three-dimensional quality of objects in a work of art.

Texture

Texture, whether in painting sculpture, architecture or any other work of art, means the treatment of the surface to create or evoke tactile experiences.

These tactile experiences originate in the way we learn about the surfaces of objects by touching them with our hands or brushing against them with other parts of our skin.

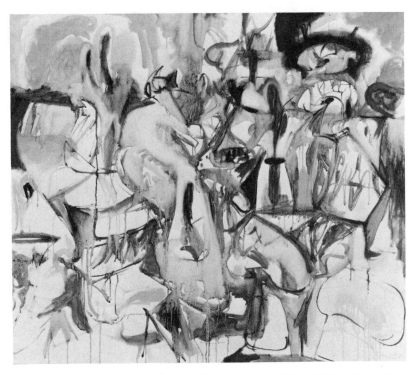

Figure 5.2 ▼ Arshile Gorky (American (1905–1948), *How My Mother's Embroidered Apron Unfolds In My Life,* 1944. (Oil on canvas, H. 40 in.; W. 45 in. By kind permission of the Seattle Art Museum, gift of Bagley and Virginia Wright.)

Real Textures

The textures in a work of art may be *real*; that is, the work of art may really have surfaces that *feel* as well as *look* fluffy like hair or soft and flexible like fabric. For example, the base of the bronze *Thinker* by the French sculptor Auguste Rodin **(Figure 5.3)** looks like a hardened lump of roughly modeled clay or plaster; if you could touch it, you would feel the same hard lumps and bumps your eyes tell you are there. This is an actual tactile experience that was created by the artist.

Simulated Textures

But more often, the textures in a work of art are *simulated*; that is, through the use of line or light, the textures *look* real, but if you touch them, *do not feel* like the textures they mimic. Take a look at the marble bust of the Grand Duke of Tuscany from the workshop of the Italian Mannerist goldsmith and sculptor, Benvenuto Cellini **(Figure 5.4).** In particular, look at the way in which the artist has carved the thick curls of the duke's hair, the crisp curls of his beard, and the soft folds of his cloak, modeling the surface into complex forms whose edges catch the light. These textures look real. But if you should actually touch the face or shoulder of this carved figure, your fingers would feel—not thick curls, not crisp whiskers, not soft cloak, but hard marble. The tactile sensations that you feel while looking at this sculpture are evoked sensations, from your memories of previous sensory experiences. When you look at these simulated textures, your fingertips may almost seem to tingle, because you know what these textures would feel like. You, along with most human beings, have touched hair and fabrics in your life before, as well as many other kinds of textures, and you have a wealth of tactile memories to call up.

It does not seem to matter whether your tactile memories exactly correspond to the simulated textures in a work of art. For example, look at the *Still Life with Partridge, Gloves and Cross-bow Arrow* that was painted nearly 500 years ago by an Italian artist from Venice **(Figure 5.5).** Probably few of you have had the specific experiences of touching 16th-century metal gloves or a cross-bow arrow, and yet it is likely that you will have little difficulty in responding to the tactile qualities of these painted objects, because of your tactile memories of touching similar objects—perhaps shiny metal cans, small metal rivets and hinges, feathers, or wrought iron bars.

The textures that you respond to in painting are usually achieved through a combination of the use of line and light. If you look carefully at the *Still Life with Partridge, Gloves and a Cross-bow Arrow*, you will see that the edges of the arrow, the wristpieces of the gloves, the bird's feet, and the piece of folded paper at the lower right are defined by line. White highlights are used on the back of the upper metal glove to indicate how highly pol-

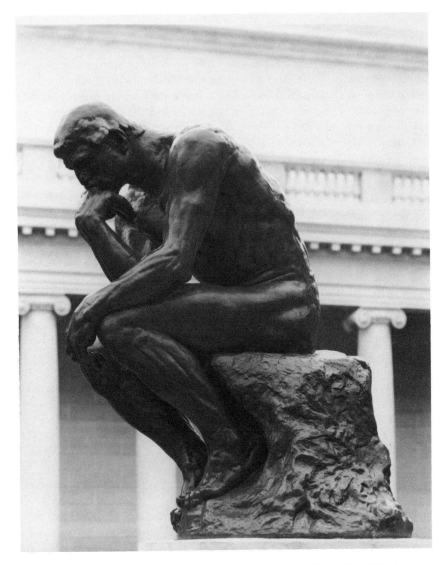

Figure 5.3 ▼ Auguste Rodin, (French, 1840–1917), *The Thinker,* ca. 1880, cast ca. 1904. (Bronze, 72 × 38 × 54 in., THE FINE ARTS MUSUEMS OF SAN FRANCISCO, Gift of Alma de Bretteville Spreckels, 1924.18.1.)

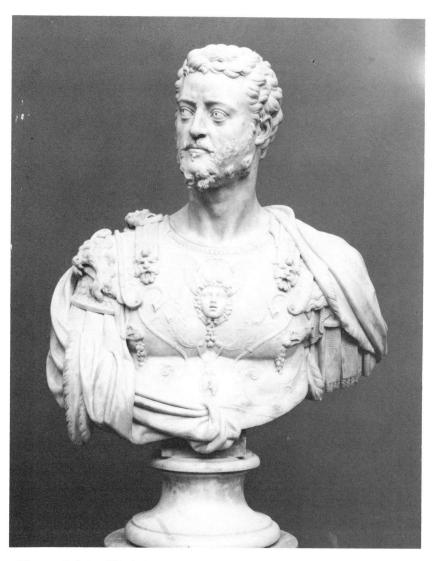

Figure 5.4 ▼ Workshop of Benvenuto Cellini, (Italian, Florence, 1500–1571), *Portrait Bust of Cosimo I de'Medici, Grand Duke of Tuscany,* ca. 1548–1583. (Marble, H: 30 in. [76.2 cm], THE FINE ARTS MUSUEMS OF SAN FRANCISCO, Roscoe and Margaret Oakes Collection, 75.2.16.)

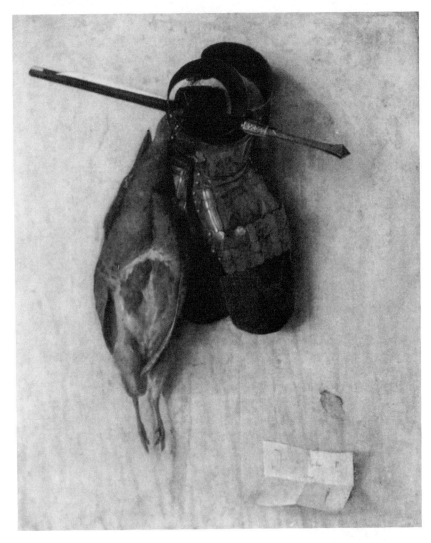

Figure 5.5 ▼ *Still Life with Partridge, Gloves, and Cross-Bow Arrow,* 1504, by Jacopo de'Barbari. (By kind permission of the Alte Pinakothek, Munich.)

ished and smooth the surface is. You can see line and light used very lavishly to evoke a wealth of tactile sensations in a similar still life with dead game and weapons, painted in 1885 by the American artist William Harnett **(Figure 5.6)**. *After the Hunt* serves up a rich array of contrasting textures provided by line and light: the soft fur and feathers of the dead game animals, the inlaid metal of the dagger, pistol and rifle, the dented metal of the French horn, canteen cover, the rusted metal of the hinges, lockplate, key, horseshoe, and nail, the different wood grains of the door and the walking staff, the soft fabrics of the hat and bag, and the porous surfaces of the antlers and powder horn.

Textures are part of the quality of a work of art. The way in which surfaces in a work of art are manipulated can create tactile sensations or evoke memories of previous tactile experiences. These sensations are important to the quality of art.

Questions on Textures

Here are some questions to help you focus on the tactile qualities of a work of art.

a. Are there actual textures in the work of art? Do you see the actual textures of paint, cloth, or anything else on the surface of your work? These have the power to create tactile experiences and should be taken into account in evaluating the quality of a work of art.

b. Are there simulated textures in the work of art? The way the surfaces of the work are treated can evoke previous memories of tactile experiences. These contribute to the quality of a work of art.

c. Are there numerous contrasting textures in the work, making it sensuous? Real or evoked tactile experiences refer to sensory experiences and are therefore considered sensuous. When a work contains many contrasting textures, it is sensuous.

Mass: The Size and Weight of Objects

Mass, in a work of art, means a solid object. It refers to the size and weight of these objects.

We learn about solid objects through a combination of sensory experiences that is partly tactile and partly visual. We have seen already that we learn about the edges and surfaces of objects through tactile experiences which may then be evoked in a work of art through the use of line or light. We learn about the size and weight of objects by wrapping our arms around them and hefting or lifting them, thus bringing the pressure sensors in our skin in touch with them. We also learn about the size of objects by visually comparing them to the size of other objects. These sensations are evoked in a work of art, like the qualities of edges and textures, through line and light.

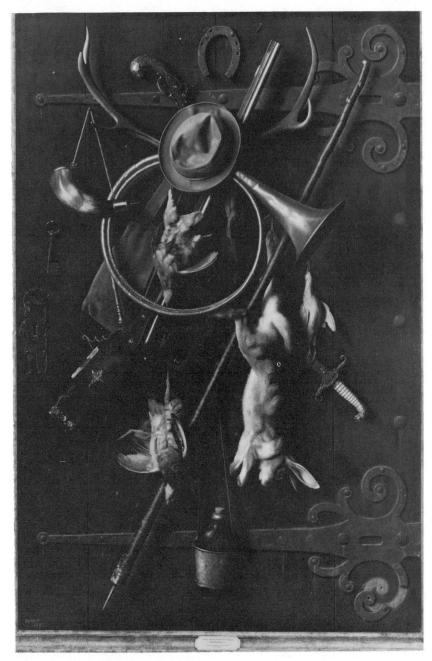

Figure 5.6 ▼ William Harnett, (American, 1848–1892), *After the Hunt,* 1885. (Oil on canvas, 71 ½ in. × 48 ½ in., THE FINE ARTS MUSEUMS OF SAN FRANCISCO, Mildred Anna Williams Collection, 1940.93.)

For example, look at *Quince, Cabbage, Melon and Cucumber* by Juan de Sanchez Cotán **(Figure 5.7)**. The mass and heft of the hanging quince fruit and cabbage head is conveyed through the edges that define their relative sizes, and through the highlights and shadows that make them appear three-dimensional. In this painting, the artist seems to be playing with the idea of the heft of these two particular objects, as he makes them float above the groundline of the sill, hanging from two slender cords. We can almost feel the strain in those cords, as if we were holding the fruit and vegetable suspended. The melon and cucumber are sitting firmly on the sill, as indicated by the shadows their solid forms cast.

Another example of strain suggested by the heft of an object is provided by the *Young Bacchus* by Caravaggio **(Figure 5.8)**. The large glass full of wine that is being offered to the viewer by the young god is suspended in midair at arm's length, held only by the god's first two fingers and a thumb. The relative size of the glass and the quantity of liquid contained within it combine to suggest a certain heft that would not easily be supported at arm's length, and we can almost feel the strain in our own muscles. Caravaggio also has played with the idea of the heft; little circular ripples are painted on the surface of the wine, indicating that the god's hand is trembling, perhaps from the strain. The sensory memories of size and heft that are evoked by these forms are part of the quality of these works of art. You can see the strain relieved in another version of this subject by a Dutch painter influenced by Caravaggio in Hendrick ter Brugghen's *Bacchante with Ape* **(Figure 5.9)**. Ter Brugghen has rested the drinking vessel on the knee of his figure.

Questions on Mass (Size and Weight of Objects)

Here are two questions designed to focus your attention on the way in which mass—the size and weight of objects—is indicated in a work of art.

a. Are size and weight indicated by the use of lines around the edges of objects? This is a tactile way to indicate mass. If line is used to indicate size and weight, then your sensory experiences being evoked are tactile.

b. Are the size and weight of objects indicated by the use of high-lights and shadows? This is a visual way of indicating mass. Highlights and shadows evoke your sensory memories related to vision.

Like your tactile sensory experiences, your sensory experiences of vision provide a vast fund of memories. Your visual memories are evoked by the forms of a work of art through the handling of space, light, and color. These are such important elements of art that we will devote the whole of the next chapter to the ways that you acquire your visual experiences, and we will discuss how these experiences affect the handling of space, light, and color in works of art.

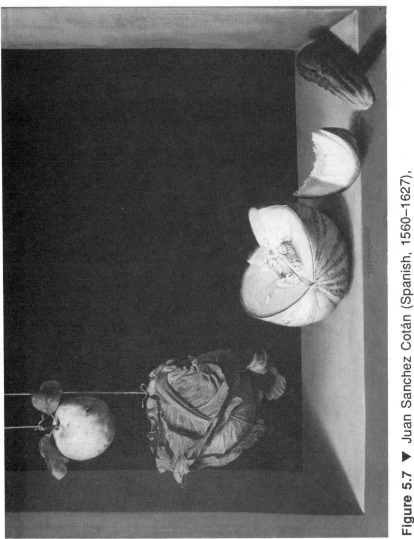

Figure 5.7 ▼ Juan Sanchez Cotán (Spanish, 1560–1627),
Quince, Cabbage, Melon and Cucumber, c. 1602. (Oil on canvas,
H: 27 1/8 in. × W: 33 1/4 in. [69.0 × 84.5 cm] SAN DIEGO MUSEUM
OF ART. Gift of Anne R. and Amy Putnam.)

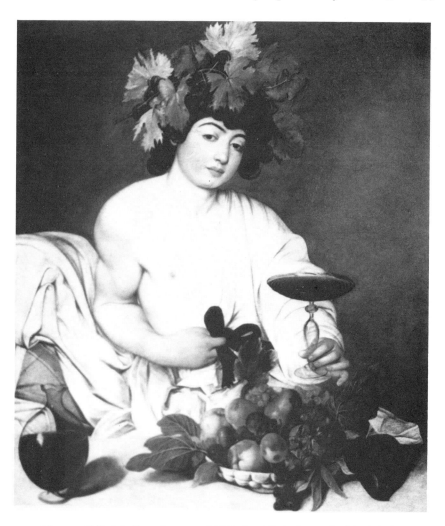

Figure 5.8 ▼ *Bacchus,* c. 1600, by Michelangelo Merisi da Caravaggio. (By kind permission of the Galleria degli Uffizi.)

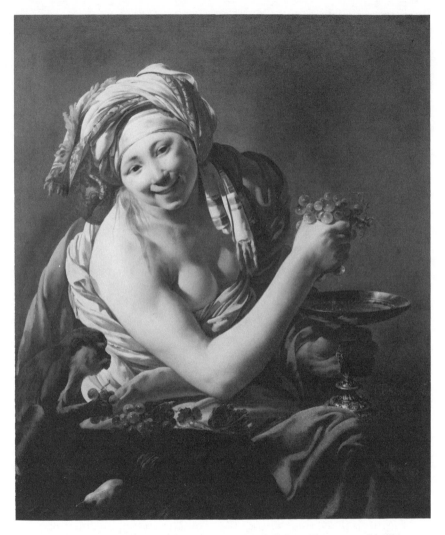

Figure 5.9 ▼ Collection of The J. Paul Getty Museum, Malibu, California. Hendrick ter Brugghen, *Bacchante With an Ape,* 1627. (Oil on canvas, 40 ½ × 35 ½ in., 102.9 × 90.1 cm.)

Notes

[1]The concept of sensory fatigue as the basis for special design principles was suggested by the British aesthetician, Stephen C. Pepper, in his *Principles of Art Appreciation* (New York: Harcourt, Brace and World, 1949).

[2]For a very full discussion of the use of line from the viewpoint of a practicing artist who is also an articulate writer, see Nathan Goldstein's *The Art of Responsive Drawing* (Englewood Cliffs, NJ: Prentice-Hall, 1984, 3rd. ed.), Chapter 1, "Gestural Expression," and Chapter 3, "Line."

Further Reading

Greenberg, Clement. *Art and Culture: Critical Essays*. Boston: Beacon Press, 1961. In particular, see the essays: "Abstract, Representational, and so forth," and "American-type Painting."

Chapter 6

▼ ▼ ▼ ▼

The Visual Experiences of Formalism

And God said, Let there be light: and there was light. —Genesis 1:3

Brightness falls from the air; Queens have died young and fair.
—Thomas Nashe

Rage, rage against the dying of the light. —Dylan Thomas

The Visual Experiences of Formalism

Light is the single most important stimulus to human sensory experience on our planet. Its primary importance is recognized in every civilization and culture. Light for many is a symbol of life. It is the first of God's creations in the Bible, and its loss symbolizes death in numerous poems. The way that light is perceived by our eyes provides the sensory experiences of sight that are evoked in works of art.

Our sensory experiences of sight are called visual experiences.

The handling of space, light, and color in a work of art evokes our *previous* visual experiences. The handling of color, alone of all the aspects of form, may also create an *immediate* visual experience. All of these sensory experiences depend upon the way our eyes respond to the stimulus of light.

The Nature of Light

Light is the visible band of the vast spectrum of different radiations, or electromagnetic wavelengths, bombarding our planet daily from the sun and the rest of the universe. Visible light is only a narrow segment of this spectrum. The order of the spectrum, portions of which can also be generated here on earth by various devices such as light bulbs, heaters, and radios, includes 60-cycle electric power, radiant heating, radio waves, infrared rays, light rays, ultraviolet rays, x-rays, gamma rays, and secondary cosmic rays. As you may have noted, the wavelengths of the visible band lie between the wavelengths of infrared and ultraviolet on the spectrum.

The wavelengths of light bounce off objects and pass through the lenses at the front of our eyes to be perceived as images on the retina at the back of the eye by light-sensitive receptors called rods and cones. The energy of the light wavelengths produces a chemical change in these receptors which is subsequently converted to an electrical current and passed along the optic nerves to the cerebral cortex in the brain. The brain stores these as images, and the stored images then form the vast fund of previous visual experiences that may be evoked by the handling of space, light, and color in a work of art.

Rods and Cones

The rods and cones in our eyes perceive light in different ways. The rods, of which there are 120 million in an eye as compared to 7 million cones, are spread all over the retina and perceive light only, not color. That is why you cannot see colors by moonlight. The weak light of the moon is enough to stimulate the rods, but not the cones. Although rods cannot be used for sharply focused vision, they operate very well in weak light, and are much

more sensitive than cones to flicker and motion. This is one kind of visual image that is stored in the brain. These images may be evoked in works of art which depend for their effect upon softly focused forms, forms in black and white, or forms which appear to flicker like Picasso's angular shapes in *Guernica* (**Figure 1.2**) and *Les Demoiselles d'Avignon* (**Figure 4.6**).

Different kinds of images are stored through the different way that cones perceive light. The cones work best in strong light, and are the only receptors that are capable of sharp focus and color vision. A large number of cones are packed into a little depression called the fovea ("pit") at the back of the eye where the inner layer of the retina does not grow, so that the cone receptors in this region have unrestricted access to entering light frequencies. The cones in the fovea are used for sharply focused vision, and the eyes will be directed toward an object until the light rays bouncing off the object fall directly on the fovea. This makes sharply focused images that are also in color, and are stored in the brain to be evoked later by forms in art that are in color and sharply focused.

As with the skin receptors, the rods and cones in the eyes will also adapt to a continuously applied stimulus and cease to respond because of sensory fatigue. If you could force yourself to stare fixedly at an object, the light frequencies bouncing off it to your eyes would act as a continuously applied stimulus, and after a while you would cease to see the object. But in fact the eyes are never stationary for more than a fraction of a second. They move away from the object being focused on, both in short irregular movements and in slow drifts, and then, in little flicks of movement, the eyes are brought back into focus on the object. In addition, because of the small size of the fovea in the eyes, the area of an object that can be sharply focused is not very large—about four inches wide if the eyes are focusing from about six feet away—and the eyes have to keep scanning until they take in the whole object. The special ways that the eyes perceive objects in these constant movements determines how we perceive spatial relationships, and results in the images stored in the brain.

The Handling of Space in a Work of Art

Space, in a work of art, refers to the spatial relationship of objects to each other and to the viewer.

We don't really see space, but objects in relation to each other and to ourselves. You might have guessed this because scientific perspective, the method discussed in Chapter 3 that was developed in the Renaissance to create realism in space, uses foreshortened objects and stacked register lines of objects. We see objects in relation to each other because there are specific places on the retina that provide the fixed points needed to locate the relationship of one object to another. Our eyes constantly compare one object with another in order to find cues to our own place in the world. Perhaps it

is because we are accustomed to making comparisons that when we look at a work of art we seem instinctively to want to compare it to another work.

All objects are projected as flat images on the retina. What makes us see objects in depth in relation to ourselves are particular cues interpreted by the brain.

These depth or spatial cues include:

1) overlapping objects
2) elevated objects
3) objects with highlights and shadows
4) foreshortening
5) relative sizes of objects

Objects overlapping each other and objects with highlights and shadows on them are the same elements that you have seen used in works of art to make objects look three-dimensional. For example, despite their abstraction, we are still able to see the rocks and trees in Paul Cézanne's *Rocks in the Park of the Chateau Noir* (**Figure 6.1**) as three-dimensional in part because they overlap. Another example of overlapping may be found in the hills in the landscape *Black Place I* by the American painter, Georgia O'Keeffe (**Figure 6.2**). Overlapping may also be used in the art of landscape architecture to create recessions into space. The careful positioning of the clumps of flowers and the bridge in the Japanese Garden in Portland (**Figure 6.3**) is an excellent example of overlapping that leads the eye back into space.

The glowing highlights shining on the face and shoulder of the militiaman represented in the *Portrait of Joris de Caulerij* by the Dutch painter Rembrandt (**Figure 6.4**) creates a three-dimensional effect. Another example of modeling in highlights and shadows can be seen in the mantles of the saints in *The Four Apostles* by the German Renaissance painter, Albrecht Dürer (**Figure 6.5**). These three-dimensional effects are also spatial effects because a three-dimensional figure must occupy space.

Elevated objects means that when one object is seen higher than another, the higher object is interpreted as being farther away from the viewer. You have noted the use of elevated objects in art before when we discussed stacked register lines as a component of linear perspective (Chapter 3). You can see another example of the use of elevated objects to achieve recession into space in the *Parable of the Sower* by the 16th-century Dutch painter Pieter Bruegel the Elder (**Figure 6.6**), which shows houses, churches, castles, and mountains elevated on the surface of the canvas to suggest a recession into space. The brain also interprets the slightly different views of the same object presented simultaneously by our two eyes as a cue to see the object in depth.

But the most important cues to see objects in depth are through foreshortening and the relative sizes of the objects. As you already know from our study of realism (Chapter 2), foreshortening means the changed appear-

Figure 6.1 ▼ Paul Cézanne (French, 1839–1906), *Rocks in the Park of the Chateau Noir*, c. 1898. (Oil on canvas, 24 × 31⅞ in., [61 × 81 cm], THE FINE ARTS MUSEUMS OF SAN FRANCISCO, Mildred Anna Williams Collection, 1977.4.)

Figure 6.2 ▼ Georgia O'Keeffe, *Black Place #1,* 1944. (Oil on canvas, 66.0 × 76.6 cm., 26 × 30$^1/_8$ in., San Francisco Museum of Modern Art, Gift of Charlotte Mack.)

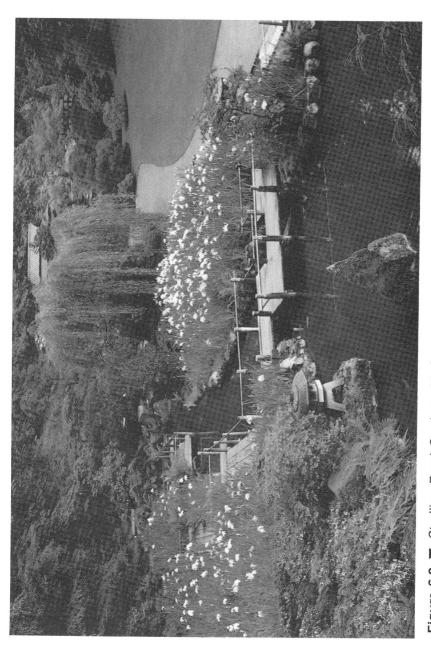

Figure 6.3 ▼ *Strolling Pond Garden with Snow Viewing Lantern.* (By kind permission of the Portland Japanese Garden Society/ William Robinson.)

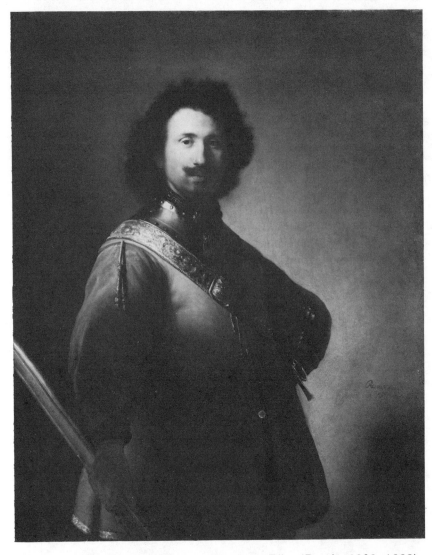

Figure 6.4 ▼ Rembrandt Harmensz van Rijn, (Dutch, 1606–1669), *Portrait of Joris de Caulerij,* 1632. (Oil on canvas, laid on wood, 40 ½ in. × 33 ³⁄₁₆ in., THE FINE ARTS MUSEUMS OF SAN FRANCISCO, Roscoe and Margaret Oakes Collection, 66.31.)

Figure 6.5 ▼ *The Four Apostles,* 1526, by Albrecht Dürer. (By kind permission of the Alte Pinakothek, Munich.)

Figure 6.6 ▼ Pieter Brueghel the Elder, *Parable of the Sower,* 1557. (Oil on panel, 29 × 40½ in. Putnam Foundation, Timken Museum of Art, San Diego, California.)

ance of an object when it is viewed from different angles. The cues of foreshortening and relative sizes both depend upon familiarity with the object.

Familiarity with the object means that we have seen the object before, and have stored its image in our brain. The ability of the brain to store images of objects we have already looked at is important to the ability to see objects in depth, or, as we say, foreshortened objects. Unless there is a stored image of the object as we saw it a while ago to compare with the object as we are looking at it now, the eyes will not be able to tell if its appearance is changed from the last time we saw it.

For example, suppose you put a round plate on a table and, standing over it, observe it from above so that what you see, and the image your brain stores, is something in the shape of a flat, round circle.

Now change your point of view. Sit at the table and put your head down about level with the edge of the plate, so that what you see, and what your brain records, is an oval shape.

You know, because you previously saw and recorded the shape of the plate as a round circle, that the plate has a round circular shape. Your brain compares the two images. Your brain tells you that the oval shape you are looking at now is not a flat oval shape, but a round shape seen from a different viewpoint. Your brain is telling you that this is a foreshortened circular object, not a flat oval. A good example of foreshortening appears in the painting of a car, called *Alameda Gran Torino,* by the American Photorealist, Robert Bechtle **(Figure 6.7),** showing the wheels of the car as oval shapes to indicate that they are foreshortened.

The cues of relative sizes also depend upon familiarity with the object. For example, given a painting of two humans, one the same proportions but much smaller than the other, your brain will tell you that the smaller one is farther away, because it has seen and recorded the human image before, and knows how big it is supposed to be. You can see this cue of relative size given in the painting called *Orange Sweater* by the Bay Area painter, Elmer Bischoff **(Figure 6.8),** where the two figures are shown in two different sizes, indicating a jump in space between them.

These different ways or cues by which we as humans perceive the relationships of objects to each other and to us are evoked in a work of art through the different ways selected to handle space. The method of aerial perspective that is used to create realism in space makes objects look farther away by showing them in smaller size. In addition, the method of aerial perspective makes use of another phenomenon of vision by showing distant objects with fewer details and bluer in color. When wavelengths of light bounce off distant objects, some will scatter before reaching the eyes, thereby causing the image to be less detailed. It is the red end of the spectrum that tends to scatter first, so the wavelengths reaching the eye seem bluer.

Figure 6.7 ▼ Robert Bechtle, *Alameda Gran Torino*, 1974. (Oil on canvas, 121.0 × 175.3 cm., 48 × 69 in., San Francisco Museum of Modern Art, T. B. Walker Foundation Fund Purchase in Honor of John Humphrey.)

Figure 6.8 ▼ Elmer Bischoff, *Orange Sweater*, 1955. (Oil on canvas, 123.2 × 144.8 cm., 48¹/₂ × 57 in., San Francisco Museum of Modern Art. Gift of Mr. and Mrs. Mark Schorer.)

Questions Concerning the Handling of Space

Because space, or rather spatial relationships, are so important to us as humans as we move around upon this planet, we have many kinds of images relating to space stored in our brains. All of these images relating to space derive from visual experiences provided by light wavelengths bouncing off objects and entering the eyes. These are experiences and images that are very important to art, as so many forms in a work of art may evoke these experiences and images. We have seen already in our discussion of the approach of realism that considerations of spatial relationships are important to a human understanding of reality. As a result, there are many questions that you need to ask yourself concerning the handling of space in a work of art:

a. Are objects shown overlapping in the work of art? Overlapping is one spatial cue interpreted by the brain.

b. Are objects elevated above each other to indicate depth? The brain interprets elevated objects as being farther away in space.

c. Are objects shown with highlights and shadows? Objects shown with highlights and shadows are interpreted as being three-dimensional by the brain, and thus inhabiting space.

d. Are objects shown with foreshortening? Foreshortening refers to the changed appearance of an object when it is viewed from different angles. It is one of the cues interpreted by the brain as indicating depth.

e. Are the objects in different sizes to indicate a spatial relationship? Relative sizes of objects provide the brain with another cue to space perception, with smaller objects of known size being interpreted as being farther away from the viewer than larger objects.

f. Is linear or scientific perspective used in your work? Linear perspective is the combined use of stacked register lines and foreshortened objects to create spatial relationships. Scientific perspective is a linear perspective in which the edges of foreshortened objects at right angles to the register lines in a picture are shown uniformly converging toward one or more vanishing points. Both linear and scientific perspective use the spatial cues of elevated objects and foreshortening that are interpreted by the brain as indications of depth.

To determine whether your work is using scientific perspective, locate the transversals, orthogonals, and vanishing point or points.

Transversals are the stacked register lines in a scientific perspective. Orthogonals are the lines along the edges of objects at right angles to the register lines that, if extended, would uniformly converge at one or more vanishing points. The vanishing point is the point at which the orthogonals of a scientific perspective converge.

g. Is aerial perspective used in your work? Aerial perspective makes objects look farther away by showing them in smaller size, with fewer details, and bluer in color. Aerial perspective is sometimes called atmospheric per-

spective. Smaller size objects are interpreted by the brain as being farther away from the viewer.

The Handling of Light

Light means the use of highlights and shadows in a work of art.

It is light that makes possible the perceptions of the spatial relationships of objects discussed above as the handling of space. Light, of course, may also be perceived as color. That is a major aspect of the handling of light that we will defer to the discussion of color below. Here we will discuss the handling of light simply in terms of its brightness or luminance. Brightness refers to the quantity of light and the intensity of the visual experience.

The distinctions between light and dark appear to be more fundamental to humans than different colors, because distinctions between light and dark, called tone or value distinctions, were named first in human vocabularies, before color distinctions. When Homer spoke of the "wine-dark sea" in the Odyssey 28 centuries ago in Greece, he seems to have meant that the sea was dark, not that it was the ruby red hue of a Cabernet Sauvignon. Many color terms are missing in Homer's epics and in other ancient works of literature, although other terms for distinctions between light and dark tones are present.

You have already learned in our discussion of space that one of the cues interpreted by the brain to determine whether or not an object is three-dimensional is the presence of highlights and shadows. There is another aspect of highlights and shadows that needs to be considered, apart from its use as a depth cue, and that is the contrast of light and dark tones or values. Tones or values refer to the quality of brightness or the amounts of light and dark present in the highlights and shadows. In some works of art, the contrast of light and dark tones is minimized by making a gradual transition from light tones to dark tones.

A very gradual and gentle transition from light to dark in a work of art is sometimes called **sfumato,** the Italian term for "smoke". It usually applies to paintings or the graphic arts. You can see an excellent example of a gentle transition of values in the highlights and shadows applied to the limbs of the reclining female figure in the *Venus d'Urbino* by the Renaissance painter, Titian **(Figure 6.9).**

In other works of art, the transition is more abrupt, creating a strong contrast of light and dark tones. Strong, dramatic contrasts between light and dark tones are usually called **chiaroscuro,** an Italian term that means "light-dark". Like *sfumato,* the term *chiaroscuro* usually applies to paintings and the graphic arts. It may apply to photographs. A dramatic *chiaroscuro* appears in the contemporary photograph, *Vermilion Lakes, Canadian Rockies,* by Galen Rowell **(Figure 6.10)** that shows brilliant highlights and deep shadows on the clouds and reflections.

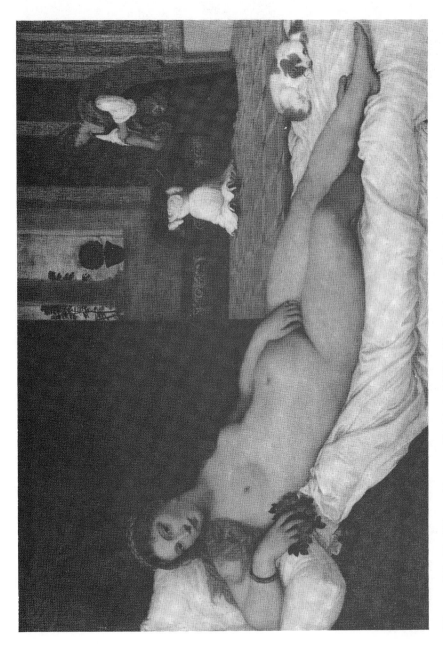

Figure 6.9 ▼ Titian, *Venus d'Urbino*, 1538. (By kind permission of the Galleria degli Uffizi.)

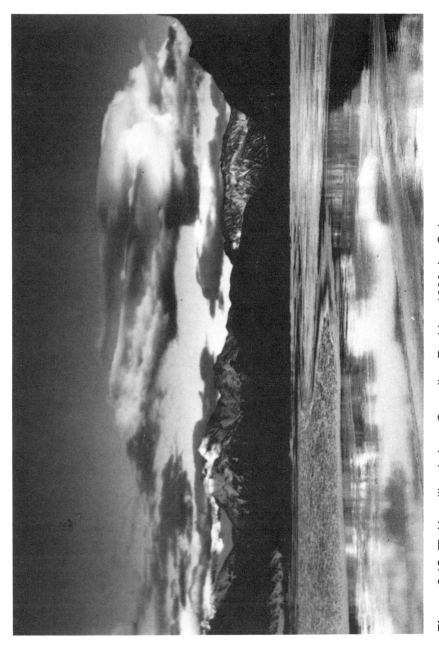

Figure 6.10 ▼ *Vermilion Lakes, Canadian Rockies*, 1986, by Galen Rowell. (By kind permission of Galen Rowell/Mountain Light.)

Intensified Light-Dark Contrast

Strong contrasts of light and dark tones evoke a particular phenomenon of visual experience: **intensified light-dark contrast.** When our eyes view areas of strong light and dark tones, the contrast is intensified. This occurs through a process of inhibition of the sensory receptors. When energy from the entering light rays is converted by one cone or rod into electrical energy, the resulting slight discharge of energy inhibits the conversion of a neighboring cone or rod. This means that an area of light tone will appear lighter against a dark-toned background than against a light-toned background. You can see that the face of Rembrandt's son seems to glow like an incandescent lamp against the dark background the artist used in the painting *Portrait of Titus* **(Figure 6.11).**

Contrasts of light and dark tones also help in space perception in a different way than the use of highlights and shadows. Light tones make objects appear to come forward toward the viewer, while dark-toned objects of equal size will be seen to recede from the viewer. A similar effect is achieved by warm and cool hues in colored objects, as we shall see.

Questions Concerning the Handling of Light

Remember that light also refers to the handling of space and color. What you need to consider here are questions referring to brightness or luminance in the work of art.

a. Do the light and dark tones in the work of art gradually grade into each other? Gradual, gentle transitions from light to dark in the highlights and shadows of a work of art evoke visual experiences of diffuse light, fogs, or smoke.

b. Do the light and dark tones in the work show a strong contrast? Strong contrasts of light and dark tones evoke visual experiences in which contrasts are intensified.

The Handling of Color

Unlike all the other aspects of a work of art, the handling of color provides immediate visual experiences, and because these experiences are not evoked memories but are immediate, their sensations are the most intense. For that reason, the use of color in a work of art is often the first aspect of form to be focused on, and some people find it difficult to look any further. That is why the discussion of color has been left until last, in order to make sure that you have had the opportunity to study the other aspects of form before drowning in color's rich sensations. (Since color reproductions vary greatly in quality, we suggest that you try to look at actual works of art while studying this section of the chapter).

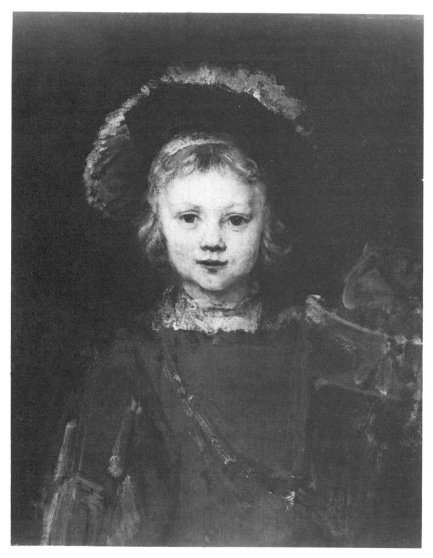

Figure 6.11 ▼ Rembrandt van Rijn, (Dutch, 1606–1669), PORTRAIT OF THE ARTIST'S SON, TITUS, c. 1645–50. (Oil on canvas, 25 ½ × 22 in., F.1965.2.P, The Norton Simon Foundation.)

When you look at a work of art and see colors, you are really seeing them. But sometimes, depending on how the colors are handled in the work of art, your eyes or your brain will modify the way you see. The artist and art professor, Josef Albers, who made a lifetime study of color, warned his students that in order to use color effectively it was necessary to recognize that "color deceives continually."

For example, observe what happens when red is placed next to green, as in Kandinsky's *Open Green* (back cover), where you can see a thin wavy red line in the top right corner laid along the edge of a large pentagon of green. Both the red and the green seem more intense where the two colors lie together side by side. Where the red line passes next to the grey and white area, it seems less intense. This is a special aspect of human visual experience that is called simultaneous color contrast.

Simultaneous Color Contrast

The principle of simultaneous color contrast refers to the apparent increase in the intensity of two opposite or complementary colors when they are placed next to each other. This contrast effect is produced through the same process of inhibition that produces the apparent strong contrasts of light and dark tones discussed above. This special aspect of human visual experience was first described in 1839 by Michel-Eugène Chevreul, a French chemist who was the director of colors at the dye works for the Gobelins tapestry factory near Paris. Chevreul's studies of color contrasts deeply influenced later generations of French painters, such as Vincent van Gogh, Paul Gauguin, Georges Seurat, and Pierre Bonnard. All of these painters deliberately used opposite colors next to each other to create simultaneous color contrasts. Simultaneous color contrasts work best, that is, the color contrasts are most intensified, if the patches of color are of substantial size or if the viewer is standing close to the patches. Otherwise, the simultaneous color contrasts will be lost in a blend of colors through another phenomenon of sight called mosaic fusion.

Mosaic Fusion

Mosaic fusion refers to the way colors, even opposite colors, will appear to blend when viewed at a distance. This is because the rays of light bouncing off the objects seen close up will touch the retina at separate points and be perceived as distinct colors by the cones. At a distance, light rays bouncing off the same objects will touch the retina at points closer together, until finally they are being perceived by the same cones, and will no longer be perceived as separate colors but as one blended color. The principle of mosaic fusion was employed by Impressionist painters, such as Auguste Renoir and Claude Monet, who deliberately juxtaposed strokes of different colors, for ex-

ample a red and a cream, knowing that the eye would blend them at a distance to create a pink. The colors created this way in Impressionist painting have a peculiar shimmering effect as they blend or separate according to how far we stand from them. Unlike the Impressionists, the painters who use the principle of simultaneous color contrast do not usually try for mosaic fusion, because opposite colors fuse into gray or black. In order to understand this, you will need to know a little more about the nature of color.

The Nature of Color

The nature of color is not difficult to understand. It is the different wavelengths of light as perceived by the cones in your eyes. Strictly speaking, objects don't have color. We see a specific color in an object when a certain wavelength of light bounces off it and is perceived by the cones. Measured in units called angstroms (A), the different color wavelengths, ranging from 7600 A down to 4000 A in the vast spectrum of electromagnetic wavelengths, are as follows:

Red (7600–6500 A)
Orange (6500–5900 A)
Yellow (5900–5800 A)
Green (5800–4900 A)
Blue (4900–4200 A)
Violet (4200–3800 A)

You will recognize these colors as the colors of the rainbow. Rainbows are caused by drops of water reflecting and bending the light to separate out the different wavelengths of the spectrum of light. We usually call the colors we perceive in the rainbow as spectral hues. There are also non-spectral hues of purple, created by mixing wavelengths from the red and violet ends of the spectrum.

Hue, Saturation, and Brightness

The different qualities of a color are identified as its hue, saturation, and brightness. Hue refers to the particular wavelength of the spectrum, meaning the name of the color: red, orange, yellow, green, blue, and violet. Saturation or purity refers to the amount of hue in a color. We use the hues we perceive in a rainbow as the standard for saturated or pure hues. Hues can range from pale to rich in saturation. Brightness, as we have seen in the discussion of light, means the quantity of light or luminance present in the color. Each of these qualities affects the other. For example, the degree of luminance affects saturation. Yellows and some greens need a high degree of luminance to appear saturated, while reds, blues, and purples appear saturated at low luminance. The human eye is extremely sensitive to all of these qualities of color,

and is capable of distinguishing very small differences in hue, saturation, and brightness, particularly with familiar objects, such as the face of someone for whom you care and see daily. You will discover that as you become familiar with a great work of art through repeated visits and study, you will be able to see much more in it, and you will be able to distinguish minute changes in the appearance of its colors at different times of day under different lighting conditions.

Color Perception by the Cones

How do your eyes actually perceive different colors? You may be amazed to learn that the cones do not have separate color receptors for all of the different colors of the spectrum. In fact, as the British physician Thomas Young discovered and published in 1802, the color receptors in the cones are actually stimulated by only three different wavelengths of the spectrum: red, green, and blue. This is called the trichromatic theory.

You might well ask, then how do we see yellow, orange, and violet? For yellow, the light wavelength range of 5900–5800 Angstroms will stimulate the red and green receptors in the cones, but not the blue receptors. The resulting mixed message sent to the cerebral cortex in the brain will be interpreted as yellow.

You can test how your color perception of yellow works as follows. If you put a red slide in one projector and a green slide in another projector, and then project the slides on a screen so that they overlap, the resulting light appearing on the screen at the overlap will be seen to be yellow. Orange works the same way but with red dominating, and violet is seen with the blue and red receptors. If the wavelengths are not separated out, we perceive the projected light to be white.

The way that we perceive colored pigments is a little different than the way we perceive colored light. We perceive colored pigments through a subtractive process. A red pigment is perceived as red because the pigment has the capacity to absorb the green and blue frequencies of light, and reflect back only the red frequency to be perceived by the cones.

Primary and Complementary Colors

Primary colors are the hues that can be mixed to make up all the other colors. Depending on whether you are working with colored lights or colored pigments, there are several sets of primary colors. If your work of art uses pigments, the primary colors are red, blue, and yellow. These can be mixed with each other or with dark and light tones to produce almost any hue on earth. If your work of art uses lights, the primaries are either red, green, and blue, or the mixtures of any two of these: magenta (red and blue), cyan (blue and green), and yellow (red and green).

Complementary or opposite colors, if you are working with lights, are any two hues which will produce a white light if mixed. The complementary colors for the primary colors in light are as follows: for a red light, the complementary is cyan blue (blue-green); for blue light, the complementary is chrome yellow; and for green the complementary is magenta red (blue-red). If you are working with pigments, the complementary colors, when mixed, will produce black. For red pigment, the complementary color is green; for blue pigment, the complementary is orange; and for yellow, the complementary is violet. Complementary pigments, when juxtaposed in a painting, are the hues which will intensify each other in the simultaneous color contrasts discussed above. Complementaries are important in art. One recent theory of color vision even suggests that the brain processes colors by means of three systems, two of which are based on complementaries: a yellow-violet system, a red-green system, and a black-white system.

After Images in Complementary Colors

If you stare at an image in a particular colored pigment for 10 seconds or more, and then look at a blank white area, you will see something that looks like the original image, but in its complementary color. For example, if you stare at a painting of a red circle for 10 seconds, then look at a blank white wall, you will see a green circle on the wall as an after image. This after image in a complementary color is the result of sensory fatigue. The receptors for the original color become fatigued after a continuous stimulus, and begin to fail, allowing the receptors for the complementary color to dominate.

Color Constancy

Sometimes your previous visual experiences will affect your present visual experience. For example, when you look at a white page under blue light, you will still see it as white, not blue. This is called the *principle of color constancy*, meaning the ability of the human eyes to adapt the color they are looking at to remain constant to the color the sensory memories tells them it ought to be. You may see this principle in operation in a work of art where an object is shown in a color that the artist knows it ought to be, not what it is; for example, a painted moonlit scene peopled by figures whose faces are painted in warm skin colors. As you learned at the beginning of this chapter, colors are not visible by moonlight.

Color Temperature and Movement in Space

In addition to the visual qualities of hue, saturation, and brightness, colors also appear to have the qualities of temperature and motion in space. We perceive the colors at the high end of the light spectrum—red, orange, and

yellow—as warm colors, and colors that appear to come towards us in space. We perceive the colors at the low end of the spectrum—green, blue, and violet—as cool colors that seem to recede from us in space.

The cause for our perception of colors as warm or cool is not known. One theory is that our visual perception of red as a warm color may be influenced by our skin sensory perceptions of infrared as heat. Red wavelengths in the light spectrum (7600–6500 A) are very close to and in fact slightly overlap the range of infrared wavelengths that the sensory receptors in our skin perceives as heat (10000–7500 A).

The reason why we perceive the warm colors as coming forward and the cool colors as receding does have a basis in physical fact. Light waves of different wavelengths reach the retina at different lengths. When the eye focuses on a red frequency, the blue and green wavelengths, being a little shorter, lie slightly in front of it. To focus on the blue and green will make the red appear to advance. Works of art frequently exploit this apparent movement of color, using warm or cool colors to make an object appear to advance or recede in space.

Questions Concerning the Handling of Color

There are many aspects concerning the use of color in a work of art. Use the following checklist to help focus your attention on some of these aspects.

a. Does the work of art show simultaneous color contrasts? Simultaneous color contrasts refer to the apparent increase in the intensity of two juxtaposed complementary colors.

b. Does the work of art use a mosaic fusion of color? Mosaic fusion refers to the way colors will appear to blend when viewed at a distance.

c. Identify the different hues used in the work of art. Hue means the name of the color.

d. Determine the saturation and brightness for each hue. Saturation refers to the purity of a hue; whether the hue is pale or rich. Brightness refers to the quantity of light present in the hue.

e. How does the work of art use primary or complementary colors? Primary colors in pigments are red, blue, and yellow. Their complementaries are green, orange, and violet.

f. How are the warm and cool colors used in the work of art? Warm colors—red, orange, yellow—appear to advance toward the viewer, while cool colors—green, blue, violet—appear to recede. Does the work of art use warm and cool colors to make objects move in space?

Colors As Universals of Art

So far we have noted that there are a number of ways in which colors may be regarded as universal factors in art. While our individual responses to col-

ors differ from person to person, depending upon our own individual sensory memories, we all experience similar perceptions of simultaneous color contrasts, mosaic fusion, the color qualities of hue, saturation, brightness, color constancy, and apparent color temperature and movement in space.

There appear to be certain psychological universals associated with some colors. The color red appears universally to be an exciting color, associated with temporarily elevated blood pressure. Blue, on the other hand, appears to be a depressive color, as it is associated with a temporarily lowered blood pressure. These psychological qualities may be exploited in the expression of meaning in a work of art.

There are some cultural universals associated with light and color as well, in the development of terms for light and color in human history. A study of light and color terms in 20 languages that was published in 1969 by two anthropologists, Brent Berlin and Paul Kay, showed that not all languages have names for all the spectral colors. In fact, the first visual distinction to be made in human language is the distinction between light and dark tones. The first hue to be named in every language is always red. The next hues to be named are always yellow and green. Then blue will receive a name. Not all ethnographic groups have a term for blue. The term for blue is followed by the term for brown. Finally, the terms for grey, orange, pink, and purple are chosen. Because of the consistency of the sequence of choice, it seems likely that the color terms were chosen in this particular order for physical or psychological reasons, having to do with the universal nature of our visual experiences, rather than for symbolic reasons associated with particular people in human history.

The Meanings of Colors

The meanings assigned to particular colors vary considerably in human history, and do not appear to be universals like other aspects of color in art. The meanings for red and blue are in part related to the universal psychological effects associated with these colors: red may signify aggression or warmth, and blue may signify depression or coolness. But mostly the meanings for colors vary, depending upon different times and places. Red could mean aggression to one person at a particular time and place, or it could mean romantic love to another person at another time and place. Blue could mean depression and coldness, or, at another time and place, the mantle worn by the Virgin Mary. In recent symbolism in California, yellow is used for the happy little cartoon face that tells you to "Have a Nice Day!" In Southeast Asia, yellow is used for the robes worn by Buddhist monks or by royalty, with all the freight of meaning carried by those institutions of church and state. There appear to be few constant meanings assigned to colors that remain the same at all times and places. This leads us to the consid-

eration of all kinds of meaning. But first, a word on the reaction against formalism.

Reaction Against Formalism

Formalism as an approach to art is not popular with art critics and art historians now in the 1990's. As one art historian notes: "Today few critics are formalists."[1] For many, it is linked with the abstract modernism of the early 20th century, and it seems irrelevant to other, newer art movements. Different kinds of expressionistic approaches are seen as more relevant to the new political and social concerns of art. In the past 20 years, there has been a reaction against formalist concerns with the arrangement and quality of the forms of art. As one *Artweek* critic asked: "Do any of these apologists for the traditionally accepted Western standards of art-making actually presume that there is a transcendent, nonhistorical notion of 'quality'?"[2]

But there is a good reason to continue to use the approach of formalism. This is the approach that, more than any other, helps you to focus carefully and systematically on the forms of the work of art. More than any other approach, formal analysis will help to develop your "eye" for art. There is no substitute for the careful, systematic observation of the work of art that this approach provides.

Formalism, however, is concerned only with the forms of art. You will learn nothing through this approach about unpacking the complex levels of meaning of a work of art. To find out about how to research the meanings of works of art, we will turn now to the approach of expressionism.

Notes

[1]David Carrier, *Principles of Art History Writing* (University Park, PA: Pennsylvania State University Press, 1991), p. 218.
[2]Lance Carlson, *Artweek* (July 18, 1991), p. 1.

Further Reading

Brent Berlin and Paul Kay. *Basic Color Terms: Their Universality and Evolution.* Berkeley: University of California Press, 1969.

Rossotti, Hazel. *Colour: Why the World Isn't Grey.* Princeton: Princeton University Press, 1983.

Chapter 7

Methods of Expressing Meaning

There is no pure art unconditioned by experience, all are shaped by experience and nonaesthetic concerns. —Meyer Schapiro

▼ Methods of Expressing Meaning
▼ Illustration ▼ Sources for Research
▼ Biography ▼ Iconography ▼ Postmodernism
▼ Structuralism ▼ Semiotics ▼ Deconstructionism
▼ Political Methods ▼ Marxism ▼ Feminist Aesthetics
▼ Choosing Your Approach to the Meaning of Art

Methods of Expressing Meaning

A work of art may express many levels of meaning, ranging from simple illustration to complex social and political symbolism. When you examine a work of art to determine its meaning, you will want to consider what it meant to the person who made it, what it meant to the person who commissioned it, what it meant to the people who first looked at it, and what it means to you here and now. The choice of method is yours. You are limited only by your own preferences. As with the other approaches to art, the approach of expressionism provides many rich interpretations. Some of these possibilities are explored here.

Illustration

The simplest way to begin to understand the meaning of a work of art is to regard it as illustration. **Illustration means that the art represents people or objects that can be identified.** Your task, then, is to identify them, and your evaluation of the meaning of the work of art will depend upon how well you think the work illustrates them. For example, look at *The Tribute Money* by Peter Paul Rubens **(Figure 7.1)**. You will see a young bearded man with a halo, pointing upwards with one hand while the other holds a coin. One white-bearded man stands at the haloed man's shoulder; the other seven men in the painting, some wearing exotic headgear, look skeptical or agitated. One man reaches out with his hands and points to the coin. Who are these people and what is that coin? If you are familiar with Christian art, you may be able to identify the young bearded man with a halo as Jesus Christ, and the white-bearded man as Peter. You may be able to recognize the story of the tribute money as a passage from Matthew 22:15–22 in the New Testament. This is the story about the Pharisees, members of a strict sect opposing Christianity, who attempted to trick Christ into refusing to pay taxes to the Roman government (the charge on which Christ was later arrested and brought to trial). The Pharisees asked:

"*Master, we know that thou art true, and teachest the way of God in truth, neither carest thou for any man: for thou regardest not the person of men. What thinkest thou? Is it lawful to give tribute unto Caesar, or not?*"

But Jesus perceived their wickedness, and said, "Why tempt ye me, ye hypocrites? Shew me the tribute money." And they brought unto him a penny. And he saith unto them, "Whose is this image and superscription?"

They say unto him, "Caesar's."

Then saith he unto them, "Render therefore unto Caesar the things that are Caesar's: and unto God the things that are God's." When they had heard these words, they marvelled, and left him, and went their way.

It should be clear from this passage that Rubens is illustrating the Biblical story with accuracy and expressive force. Accuracy because all the

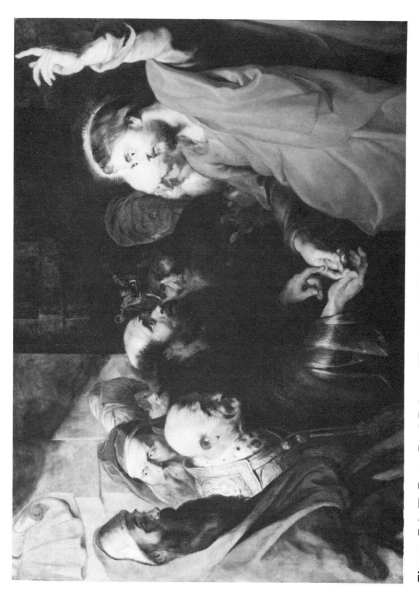

Figure 7.1 ▼ Peter Paul Rubens (Flemish, 1577–1640), *The Tribute Money*, ca. 1612. (Oil on wood panel, 56³/₄ in. × 74³/₄ in., THE FINE ARTS MUSEUMS OF SAN FRANCISCO, Purchased with funds from various donors, 44.11.)

elements are there: Christ, the coin, and the Pharisees. Expressive force because of the way in which he has placed the coin front and center in the picture and framed it with hands, and because of the variety of marvelling emotions shown in the faces of the Pharisees.

But in order to evaluate how well Rubens is illustrating the Biblical story, you need to know the story. That brings us to a consideration of the principal tools of an art critic's trade besides your eyes, that is, your sources for research.

Sources for Research

Every art critic who is planning to research works of art produced in the West at any time up to the 20th century should become familiar with the stories from the two sources of Western civilization: the Judeo-Christian tradition, and the Classical tradition of Greece and Rome. You will want to begin your own personal reference library with sources for research into these two traditions.

The single most important source for the Judeo-Christian tradition is the *Bible*. Invest in a copy for your own use, in whatever translation you prefer, but find a translation that includes the *Apocrypha*, as well as the Old Testament and New Testament. The non-canonical books of the *Apocrypha* contain stories, such as those of Tobit, Esther, or Susanna and the elders, that are also illustrated in works of art. For convenience in referencing, your translation should contain the standard chapter and verse divisions. Notations giving extra information or referring to parallel passages are useful. In order to find your way around in the *Bible*, you will need to use a special Biblical index, called a *Concordance*, which lists and identifies key terms, and cites the book, chapter, and verse where these may be found. Whenever you are studying a work that you know illustrates a Biblical story, make it a practice to look it up and read the original account. You will learn after a while that the stories chosen for illustration form a limited repertory. You will find that the same stories are illustrated over and over.

There are other sources that are important in understanding this tradition. For the stories concerning saints that you will often find illustrated in medieval art but which don't appear in the Bible, you will need to consult standard biographies, such as *Butler's Lives of the Saints*. Or you may wish to use the great medieval collection of stories called *The Golden Legend*, written in 1280 by Jacobus de Voragine. Standard encyclopedias, such as the *Encyclopedia Britannica*, also provide useful information on individual saints.

The Classical tradition of Greece and Rome requires that you become familiar with the myths of the gods and goddesses and the stories out of Greek and Roman history. You will need to invest in a good mythology, such as Robert Graves's *The Greek Myths*, or the *Larousse Encyclopedia of Mythology*. Whenever possible, try to consult the Classical sources referred to in

these mythologies, for example, Homer's *Iliad* and *Odyssey*, or Ovid's *Metamorphoses*. You will also need to make the acquaintance of the figures from Greek and Roman history. Good Classical sources to purchase for your own reference library would be Plutarch's *Lives* and Suetonius's *The Twelve Caesars* by Suetonius. If you have not read Classical biographies before, you will find them surprisingly entertaining and scandalous. You may also consult a standard encyclopedia for brief biographies of Classical personages, or use one of the specialized Classical biographical dictionaries, such as *Who Was Who in the Greek World* or *Who Was Who in the Roman World*. Make it your usual practice to look up whatever myth or personage is illustrated in the work of art that you are examining.

For works of art that do not illustrate Biblical stories, stories of the saints, or Classical myths and history, you will need to try other research tools. If the title of the work indicates that it represents a particular person, object, place, or event, try looking these up first in a standard encyclopedia, and then in whatever sources are suggested by the encyclopedia article.

You will find it very useful to invest in a history of art that is amply illustrated and has a good index and bibliography, such as H. W. Janson's *History of Art* or Helen Gardner's *Art Through the Ages*. Better yet, take a general art history survey course, and as many specialized art history courses as you can, in order to provide yourself with the opportunity of adding to your repertory of stories as well as your visual memories of art that will then give you something to refer to whenever you look at a new work. The repertory of stories illustrated in Western art is limited, and a good art history survey course will provide you with illustrations of most of them.

The approach of illustration is the usual approach for many art critics and most art historians. It certainly makes sense to begin your analysis of the work's meaning by identifying what is illustrated. But if the work of art does not contain identifiable persons or objects, you will need to choose another approach to understanding its meaning. A contemporary approach favored by many critics is the approach of biography.

Biography

The approach of biography means the concept that the work of art expresses some aspect of the personal life of the artist. These aspects of the artist's life may include the emotions of joy, desire, love, anger, anguish, despair, disgust, or personal attitudes, celebrations, traumas, or illnesses. For example, the figure seen in *Adolescent by the Bed* (1959) by the West Coast artist, Nathan Oliveira (**Figure 7.2**), seems expressive perhaps of some private emotions or memories of desire, certainly not of a commercial calendar pinup figure. It shows a young nude girl, unsmiling, with her hair concealing her eyes and paint dripping like blood down her legs, who stands next to a

Figure 7.2 ▼ Nathan Oliveira, *Adolescent by the Bed,* 1959. (Oil on canvas, 153.0 × 152.7 cm., 60 ¼ × 60 ⅛ in., San Francisco Museum of Modern Art, William L. Gerstle Collection, William L. Gerstle Fund Purchase.)

grim iron cot with stained sheets. To verify this impression, you would have to check the published details of Oliveira's life.

If you decide to use biography as your approach to meaning, there are plenty of resources for you to consult. For a well-known contemporary artist, try the annual *Current Biography*, containing long articles on individual artists plus a photo, or the biannual *Who's Who in American Art* with shorter entries. For other artists, there is the *Biography Index*, containing numerous recent bibliographies of articles. Biography is a traditional approach to art criticism, beginning with the publication in 1568 of the *Lives of the Italian Painters, Architects, and Sculptors* by Giorgio Vasari, and there are many collections of biographies on Vasari's model. You have already seen an excellent example of this approach in Herschel Chipp's discussion of Picasso's *Guernica* (**Figure 1.2**). But be warned if you choose this method. There are some drawbacks.

While there are sometimes very close correlations between an artist's work and the private details of an artist's life, sometimes there are not. For example, you might want to interpret as expressing despair or insanity the use of bold black lines and juxtaposed complementary colors—reds against greens, blues against oranges—in works by the Dutch artist Van Gogh, because it is well-known that he spent time in mental institutions and finally committed suicide at 37. Yet if you read his correspondence to his brother Theo, you will find that he painted when he was sane, not insane. His contemporary, the French painter Paul Gauguin, also employed bold black lines and complementary colors, but was not considered insane.

If you still believe that a person has to be insane to be an artist, you need to read a very useful survey by Rudolf and Margot Wittkower of the lives of artists in all periods and places, called *Born Under Saturn: The Character and Conduct of Artists*, that documents their thesis that artists come in all varieties of psychological health, ranging from the certifiable Van Gogh to Peter Paul Rubens, a career diplomat and millionaire entrepreneur.

Iconography

Iconography is the study of the symbolic meaning of people or objects. It carries the approach of illustration to a more profound level. To take an example of the difference between the methods of illustration and iconography: identifying the theme of Leonardo's famous painting in Milan as the Last Supper, and identifying the thirteen men around the table as Christ and the twelve apostles is an example of the method of illustration.

"But when we try to understand it," said Erwin Panofsky (1892–1968), the German art historian who was the founder of iconographic studies in the United States, "as a document of Leonardo's personality, or of the civilization of the Italian High Renaissance, or of a peculiar religious attitude, we deal with the work of art as a symptom of something else.

"The discovery and interpretation of these *symbolic values* (which are generally unknown to the artist himself and may even emphatically differ from what he consciously intended to express) is the object of what we may call *iconography in a deeper sense.*" [1]

The method of iconography, as practiced by Erwin Panofsky and the generations of American art historians trained in this method since Panofsky began teaching here more than 50 years ago, means very careful scholarship, not just into the art of the period, but usually deeply into the literature as well. It encompasses an ample humanist tradition of scholarship that extends back in European history to the humanist studies of the Renaissance, and expertise in this method, still taught in graduate departments of art history, generally requires years of study and proficiency in several European languages.

This scholarly method of iconography has set the standard for the investigation of meaning in works of art, and many critics employ diluted versions of this method.

By using the approach of iconography, the sealife head of *Aqua* (**front cover**) that was discussed in Chapter 1 can be made to yield multiple meanings. Completed in 1566 by Guiseppe Arcimboldo for his patron, the Holy Roman Emperor in Prague, *Aqua* was one in a series of paintings, entitled *The Four Elements: Earth, Air, Fire, Water*. These four elements were thought by the Greeks to be the basic components of every substance in the universe. Arcimboldo painted each element as a male head compounded of forms related to that element: Earth as a composite of animals, Air as a composite of birds, Fire as a composite of flames, and Water, as you know, a composite of sealife. The heads are not portraits, but Fire is shown wearing one of the Emperor's orders. These double-image paintings were linked to another series, also painted for the Emperor by Arcimboldo, called *The Four Seasons: Spring, Summer, Autumn, Winter*. In this series, also made up of double images, Autumn is a portrait of the Emperor. Taken together, the two series of paintings constituted a gigantic metaphor and the painter's best good wishes for the extent and duration of the Emperor's reign: it should extend throughout the universe and endure throughout every season. The Emperor appreciated these visual compliments, and not only ordered several sets to distribute to important people, but gave Arcimboldo rewards on top of his official court salary as the keeper of the Cabinet of Curiosities. These double images were not unique in the 16th century. The Flemish painter Hieronymus Bosch included some remarkable double images in his altarpiece of the *Garden of Earthly Delights* in 1515. But the complexity of Arcimboldo's double images made him the undisputed master of the art pun.

Other levels of meaning for Arcimboldo's paintings have been raised by humanist scholars. The French philosopher Roland Barthes investigated the literary devices of 16th-century rhetoric, and proposed that by using a fish form to make a human nose and mouth in *Aqua*, Arcimboldo was influenced by the rhetorical figure called "antanaclasis," meaning the repetition of a word in a speech of the same sound but with a different meaning. A profes-

Figure 7.3 ▼ Willem De Kooning, *Woman,* 1950. (Oil on paper mounted on Masonite, 93.1 × 62.3 cm., 36 ⅝ × 24 ½ in., San Francisco Museum of Modern Art Purchase.)

sor of comparative literature, Giancarlo Maiorino, added to this analysis further contextuality by linking Arcimboldo's sealife head to various 16th-century literary concepts of excess, hyperbole, playfulness, extravagance, grotesque abnormality, and punning.[2]

A more modern work that may be interpreted by the analysis of its iconography is *Woman* by the Abstract Expressionist painter Willem de Kooning **(Figure 7.3)**. H. H. Arnason analyzes the series of which this is one example as "the famous series of women paintings, overpowering, at times repellent, but hypnotic evocations of woman as sex symbol, fertility goddess—and in the tradition of Edvard Munch—blood-sucking vampire."[3] (For another iconographical analysis of de Kooning's painting, see the sample art criticism by Laura L. Sueoka at the end of the book.)

These three methods just discussed—illustration, biography, and iconography—remain the classic methods to determine the meaning of a work of art. Other more controversial methods, collectively entitled postmodernist criticism and developed for the most part in the past 30 years in reaction against the approach of formalism, are the approaches we will turn to next. These postmodernist approaches include: structuralism, semiotics, deconstructionism, Marxism, and feminist aesthetics.

Postmodernism

Postmodernism refers in general to the methods of art criticism developed in reaction against the approach of formalism.

Postmodernist criticism moves away from the visual works of art to include performance arts, such as dance or music, with a focus on the critical method, not on the work of art. The most influential of the postmodernist critics of the 1980's, Rosalind Krauss (1940–), suggests that art criticism should focus not on evaluation but on method, as follows:

"Can it be argued that the interest of critical writing lies almost entirely in its method? Can it be held that the content of any evaluative statement—"this is good, important," "this is bad, trivial"—is not what serious criticism is, seriously, read for?"[4]

Krauss, who wrote reviews for *Artforum* until she resigned to found her own art journal, *October,* led the rejection of the approach of formalism, replacing it with methodologies derived from French anthropological and linguistics studies. She invites us to substitute for the concept of the work of art as an object the concept of the work as a structure, whose parts can be replaced without altering its name or its form.

Krauss also rejected the approaches to meaning that considered illustration, biography, and iconography as too static, and suggested that meaning is to be regarded as a shifting system of assumptions, as outlined by the French philosopher, Michel Foucault.

In order to review art from a postmodernist approach, you will need to study the theories of one or more of the French philosophers, anthropologists, and linguistics scholars, and then see how the works of art fit within these theoretical constructs. You will probably find that most of the pleasure of postmodernist art criticism lies in the beautiful logic of the review. By beautiful is meant the elegant structure of the review. It is as if the review becomes the work of art. The work of art is no longer the focus of criticism, but the proof of the criticism's logic. Samples of Krauss's beautiful reviews are published in her book of collected essays: *The Originality of the Avant-Garde and Other Modernist Myths* (1985).

Structuralism

Structuralism refers to the French theory of anthropology developed by Claude Lévi-Strauss in which cultural institutions are broken down into separate elements, and then examined to define their relationships.

As director of studies from 1950 to 1974 at the École Pratique des Hautes Études in Paris and a professor of social anthropology for many years, Claude Lévi-Strauss (1908–), was very influential in French intellectual circles. Much of his theoretical work concerning structuralism was based on raw material from the Americas, where he had carried out extensive field work. For example, Lévi-Strauss recorded a painted face design used by a Brazilian tribe as being what he termed a "split image," that is, a representation of something normally seen frontally—a face—which is split down the middle and depicted as two opposing profiles. He then found the use of similar split images in Native American designs of the Northwest Coast, and in bronze vessels dating back to 1300 B.C. in China of the Shang Dynasty.

Seeking for an explanation of this similarity, Lévi-Strauss rejected cultural diffusion as a possible connection because of the great difference in time and place, saying: "If history, when it is called upon unremittingly (and it must be called upon *first*), cannot yield an answer, then let us appeal to psychology, or the structural analysis of forms; let us ask ourselves if internal connections, whether of a psychological or logical nature will allow us to understand parallel recurrences whose frequency and cohesion cannot possibly be the result of chance."

He then examined the cultures of Brazil and the Northwest Coast, and discovered the connections in the structural similarities of the cultures: "in both cases, art is intimately related to social organizations: Motifs and themes express rank differences, nobility privileges, and degrees of prestige. The two societies were organized along similar hierarchical lines and their decorative art functioned to interpret and validate the ranks in the hierarchy." [5]

Amongst the most useful of Lévi-Strauss's publications, if you wish to pursue a structuralist approach to meaning in art, are these: *Structural Anthropology* (1963) and *The Raw and the Cooked* (1964).

Semiotics

Semiotics is the science of signs, the systems by which humans communicate that include language, auditory communication, gesture language and writing, and visual communication.

Semiotics provides another method for analyzing the structure of a work just as a literary text may be examined, with a view to understanding the whole complexity of meaning communicated. Roland Barthes (1915–1980), who taught the sociology of signs, symbols, and collective representations at the École Pratique des Hautes Études in Paris, described some terms of semiotics as follows:

The sign: the signified and the signifier are the components of the sign. The sign has affinities and dissimilarities with signal, index, icon, symbol, allegory.

The signified: a concept. The signified of the word "ox" is not the animal but its mental image.

The signifier: the substance of the signifier is always material, for example, sounds, objects, images.

Discourse: personal use of language to communicate thought

Text: not an object but the methodological field—"the work can be held in the hand, the text is held in language."

Polysemy: containing multiple signs (from Greek "sema," meaning "sign.")

The approach of semiotics, although generally applied more to literary works than to art, is capable of an elaborate analysis of the components of art, resulting in a greater complexity of meaning. For further explanation of this method, consult Barthes's book, *The Elements of Semiology* (1967), or his article, "From Work to Text," published in his *Image-Music-Text* (1977).

Deconstructionism

In reaction against the French analytical systems based on structural anthropology and linguistics theory, another French philosopher, Jacques Derrida (1930–), who followed Lévi-Strauss as director of studies at the École Pratique des Hautes Études in Paris, focused upon the difficulty of defining art, or, in his terms, putting a philosophical "frame" around it. His whole approach of deconstructionism in art is built upon displacing the traditional borders of art and theory. In his book, *Truth in Painting*, Derrida explained: "Deconstruction must neither reframe nor dream of the pure and simple absence of the frame. These two apparently contradictory gestures, systematically inseparable, are the true functions of what is being deconstructed here."

Deconstructionism questions all methods in order to show how we are limited by assumptions. Deconstructionism attempts to "deconstruct" all our constructions of thought. Deconstructionism sees the human frailty and rela-

tivity behind every system of thought. Like Derrida's writings, it is both playful and profoundly serious. It does not focus upon the work of art, or your response to the work, but instead upon the philosophical assumptions made by the approaches to art.

In order to be able to use deconstructionism as an approach to art, you will need to learn Derrida's vocabulary in context through his writings: *Margins of Philosophy* (1972), *Dissemination* (1972), and *Truth in Painting* (1978).

As you have seen, these three postmodernist methods of structuralism, semiotics, and deconstructionism are all the product of French intellectual life in Paris. Perhaps the best way to learn these methods thoroughly enough to make them your own as your approach to art criticism is simply to get on the next plane to Paris and plan to spend a year or so meeting French intellectuals and conversing with them. You could put in your free time looking at the collections of art in the Louvre, the Musée d'Orsay, the Musée Marmottan, the Picasso Museum, the Cluny Museum, and the Beaubourg, and, on weekends, take trips to see the architecture of Chartres, Rouen, Amiens, Versailles, Fontainebleau, and the chateaux of the Loire Valley. That way, even if you never do quite come to understand French postmodernist criticism, you will at least bring back valuable experiences of some of the world's greatest works of art.

The remaining methods to extract meaning from works of art are political in nature, rather than anthropological or linguistic in origin.

Political Methods: Marxism and Feminist Aesthetics

The political methods are based on social and economic concerns, and take the position that the expression of these concerns should be paramount for the evaluation of art, rather than the aesthetic qualities of form or the approach of realism.

Marxism

Marxism as an approach to the meaning of art implies the acceptance of the view expressed in Karl Marx's *Das Kapital* (1867) of history as a class struggle, with ultimate victory to be achieved by the proletariat on whose labor the economy of the world rests. Works of art are to be evaluated not for their aesthetic value, but for what they contribute to this ultimate victory. Art should serve the cause of socialism. At the basis of this Marxist approach is the belief that art matters politically. Art can be used as a weapon in the class struggle and ultimately win power not just for the artist but for poor and oppressed people everywhere. Perhaps this view of art as a weapon and the artist as a power in society goes back before Marx to the French Revolution, when paintings by the Neoclassical artist, Jacques-Louis David, served

as banners of propaganda to criticize the selfish hedonism of the aristocracy and to inspire the French nation with a new concept of patriotic service. As a result of his political activity, David became a member of the powerful committee of the French Revolution that signed the order to behead Louis XVI in 1793.

Mark van Proyan, an artist and the Northern California editor for *Artweek*, expressed a Marxist approach when he defined the role of the art critic: "In a capitalistic state, art is structurally defined as a commodity. In a socialistic society, art is structurally defined as propaganda. The critic should strive to see that art is seen as more than these things. Criticism is the conscience to keep institutions honest." [6] Critics who wish to explore this approach to art should become familiar with socialist theories and literature, beginning with *Das Kapital* by Karl Marx.

Feminist Aesthetics

Political empowerment is one of the concerns of feminist aesthetics. The feminist movement in art began 15 years ago with a major exhibit, *Woman Artists: 1550–1950*, organized at the Los Angeles County Museum in 1976 by Ann Sutherland Harris and Linda Nochlin to make more widely known the works of art by women artists neglected in history because of their sex. Since then feminist aesthetics has expanded its focus to include making more widely known the work of women artists of the present day currently neglected because of their sex. In the United States, feminist political activism in the arts is spearheaded by the Guerilla Girls, a group of women artists, called "The Conscience of the Art World" and disguised by hairy snarling gorilla masks, who plaster New York and other cities with meticulously printed informational messages directed at correcting the inequities of the art market. For example, Guerilla Girls West recently printed and distributed the information that the new edition of H. W. Janson's standard art history text contained 2,300 men artists but only 19 women artists.

Feminist aesthetics is particularly important as a critical approach in Germany, where much thought has been given as to what constitutes the feminist approach. As noted by the author of a book on feminist images, Silvia Bovenschen, who teaches at Frankfort University: "The question directed at a painter of why she did not portray women's demonstrations or activities in her paintings is an objectively cynical and insulting one. Such a question reduces her work to the level of photojournalism in weekly news magazines, something any man could do. Is there a feminine aesthetic? Certainly there is, if one is talking about *aesthetic awareness* and *modes of sensory perception*. Certainly not, if one is talking about an unusual variant of artistic production or about a painstakingly constructed theory of art." [7]

The academic world contains many critics writing about art from a feminist approach: the classics professor, Eva C. Keuls who analyzed Greek

vase painting in *The Reign of the Phallus: Sexual Politics in Ancient Athens* (1985); the art historian and sculptor, Merlin Stone, who wrote two books on the representation and lore of ancient goddess figures, *When God Was a Woman* (1976), and *Ancient Mirrors of Womanhood: A Treasury of Goddess and Heroine Lore from around the World* (1979); and one self-styled "ecofeminist" Suzi Gablick, whose *The Reenchantment of Art* (1991) supports art that is actively compassionate and healing. For critics desiring to approach art from a feminist viewpoint, there is ample material. The address for Guerilla Girls West is P.O. Box 882042, San Francisco, CA 94188.

Choosing Your Approach to the Meaning of Art

The methods of expressing meaning in art discussed here are just a sample of the rich possibilities available for you to consider. But as with the approaches of realism and formalism, the approach of expressionism should be carefully explored with a view to your own preferences. You should realize that there is no such thing as an objective critic or an objective approach. It is important for you to identify the choice you have already made. You will then be able to decide whether to enrich this choice, to add to it, or to replace it with another approach that appeals more to you. When you have identified and carefully considered your preferences in approach and methods, then you will be prepared to look at works of art with an informed viewpoint, and from that begin to write art criticism. The next chapter will guide you through the process of writing your own piece of art criticism.

Notes

[1]Erwin Panofsky, *Studies in Iconology: Humanistic Themes in the Art of the Renaissance* (New York: Harper and Row, 1962), p. 6.

[2]Giancarlo Maiorino, *The Portrait of Eccentricity: Arcimboldo and the Mannerist Grotesque* (University Park: Pennsylvania State University Press, 1991), p. 5.

[3]H. H. Arnason, *Modern Art: Painting, Sculpture, Architecture* (New York: Prentice-Hall, 1984), p. 522.

[4]Rosalind E. Krauss, *The Originality of the Avant-Garde and Other Modernist Myths* (Cambridge, Mass.: MIT Press, 1985), p. 1.

[5]Claude Lévi-Strauss, *Structural Anthropology* (Harmonsworth, England: Penguin Books, 1963), pp. 248–256.

[6]Mark van Proyan was speaking as a panelist at a forum on art criticism, "Critical Responsibility," sponsored by the San Francisco Art Dealers Association in San Francisco, July 10, 1991.

[7]Silvia Bovenschen, "Is There a Feminine Aesthetic?," in *Feminist Aesthetics*, edited by Gisela Ecker (Boston: Beacon Press, 1985), pp. 44, 49.

Further Reading

Barthes, Roland. *Elements of Semiology*. New York: Wang and Hill, 1967.

___. *Image-Music-Text*. New York: Wang and Hill, 1977.

Derrida, Jacques. *Dissemination*. Chicago: University of Chicago Press, 1983.

___. *Margins of Philosophy*. Chicago: University of Chicago Press, 1984.

___. *The Truth in Painting*. Chicago: University of Chicago Press, 1987.

Ecker, Gisela, editor. *Feminist Aesthetics*. Boston: Beacon Press, 1985.

Gablick, Suzi. *The Reenchantment of Art*. New York: Thomes & Hudson, 1991.

Harris, Ann Sutherland and Nochlin, Linda. *Women Artists: 1550–1950*. New York: Knopf, 1977.

Keuls, Eva C. *The Reign of the Phallus: Sexual Politics in Ancient Athens*. New York: Harper & Row, 1985.

Krauss, Rosalind E. *The Originality of the Avant-Garde and Other Modernist Myths*. Cambridge, Mass.: MIT Press, 1985.

Lévi-Strauss, Claude. *Structural Anthropology*. Chicago: University of Chicago Press, 1983.

___. *The Raw and The Cooked: Introduction to a Science of Mythology*. Chicago: University of Chicago Press, 1990.

Marx, Karl. *Capital*. 3 vols. Cutchogue, N.Y.: Buccaneer Books, 1988.

Panofsky, Erwin. *Studies in Iconology: Humanistic Themes in the Art of the Renaissance*. New York: Harper and Row, 1962.

Stone, Merlin. *Ancient Mirrors of Womenhood: A Treasury of Goddess and Heroine Lore from Around the World*. Boston: Beacon Press, 1984.

___. *When God Was a Woman*. New York: Harcourt Brace Jovanovich, 1978.

Wittkower, Rudolf and Margot. *Born Under Saturn: The Character and Conduct of Artists*. New York: Norton, 1969.

Chapter 8

▼ ▼ ▼ ▼

Writing Art Criticism

Criticism should be partial, passionate, and political, that is to say, written from an exclusive point of view, but a point of view that opens up the widest horizons. —Charles Baudelaire

Methods of Writing Art Criticism

At this point, now that you have studied the different approaches to art, you should be ready to write a piece of art criticism. Writing art criticism is a helpful way to discover more about works of art, because the process of writing makes you focus more carefully on the art. As with the approaches to art, you will find that there is a choice of methods of art criticism. Your choice will depend upon your special purpose. For most people, these purposes will probably be one of the following: writing for your own personal development, writing an academic paper, or writing a review for a newspaper or periodical.

Personal Development

If you are writing for your own personal development, you will want to choose your own approach to art from the three approaches covered in the previous chapters, and write any way that suits your own needs. You may wish to use one of the methods we suggest for writing academic papers or reviews. In any case, you might want to consider dating and filing your art criticism pieces, including reproductions or sketches of the works you have written about. That way, you will be able to refer back to your critical development over a period of time. You will enjoy noting how your eye improves and your critical powers increase. Another method for personal development would be to record your comments on a portable cassette recorder as you are examining the work of art, and then date and file the cassette for future transcribing. A helpful variation on this method would be to ask a friend interested in art to view the work with you, while you record your discussions of the work.

Fulfilling an Academic Requirement

If your purpose is to fulfill an academic requirement, you may want to try the following method. There are twelve stages in this method. The method works best if you take the steps in order as given.

12 Steps to a Term Paper

1. Ask Your Professor What the Requirement Actually Is

If the requirement is a term paper or a short paper, *write down exactly what the professor wants you to do*. It will do you no good to write a brilliant piece analyzing the forms in Kandinsky's *Open Green*, when the professor wanted you to prepare a comparison of the figures of the Last Supper in the versions

painted by Leonardo da Vinci and Tintoretto. *If the professor has prepared a handout sheet of requirements, read it carefully—very, very carefully!*

2. Make Sure You Understand Any Special Limitations

Your professor may limit the choice of artist, subject matter, period, medium, or numbers of works. Follow these limitations in your choice. If your professor wants you to write a term paper on one work of art, choose one work of art. If the professor wants you to write a comparison, choose two works of art to compare.

3. Note All Mechanical Requirements

Be sure that you know what the professor is requiring for *the length of the paper*. If the length is given in pages, find out if that means each page is expected to be typed or keyboarded in 12-point type on 8 ½ × 11-inch paper with one-inch margins, or if some other type, paper size, and margins are expected. If the length is given in a number of words, you will need to keep this number in mind, and count the number of words on your pages to be sure that you are fulfilling this requirement.

4. Be Sure You Know What the Requirements Are for the Paper's Format

For example, find out if you are required to provide a cover, a title, a title page, footnotes at the bottom of the page or notes at the end, a bibliography, a list of illustrations, and any special requirements for the illustrations. *Pay particular attention to the required format for notes and bibliography.* The choice of these formats differs considerably in the academic world. *Note the deadline for the paper.*

5. Ask Your Professor if You May Look at a Sample Student Paper from a Previous Class

Reviewing a sample student paper, if it is one that earned a good grade, will give you a useful visual concept of what your paper's format should look like. Reading it carefully and noting the comments will give you further insights into what your professor wants. See if you can determine which approach to art your professor favors.

6. Once You Understand the Requirements, Establish a Timetable for Your Paper

Work backwards from the due date. Set up a date of completion at least a week before the paper is actually due. That will give you some breathing space to accommodate last-minute revisions. If you are typing or keyboarding the paper yourself, determine how long that will take you (a generous estimate of time would be about four pages an hour). You will need to set aside additional time for typing your notes, bibliography, and list of illustrations. Then allow for at least two days of writing time per page. Then try to estimate how much time you will need for research. Allow for at least one day of research per page of the paper. This does not mean that you will be spending eight hours per day for each of these days of writing and researching the paper. But you should plan on spending at least one hour working on your paper on each of these allotted days. An hour or so per day spread out over a period of time will result in a much more thoughtful paper than a paper whose preparation is crammed into the last week before the due date.

Your timetable for a 10-page term paper might read something like this:

Due date: December 14
Date of completion: December 7
Typing or keyboarding: 4 hours on December 6
Writing (20 days): November 16–December 6
Researching (10 days): November 6–November 16

7. Choose the Subject of Your Paper

The first thing to do, once you have established a timetable, is to choose a subject, even though the time to begin researching and writing the paper may be weeks away. After you have chosen the subject, you need do nothing more until the time you have established for beginning the research and writing. The reason for the early choice is to allow the subject to tick away at the back of your mind. When it comes time to focus on your subject, you will be interested to discover what your mind has come up with in this period without any conscious thought on your part.

Be careful in choosing your subject. Check over the requirements for your paper to make sure that you understand any limitations on your choice. If there are no limitations, your best bet is to *choose a work of art that you are strongly drawn to.* By analyzing and researching a work that strongly attracts you, you will not only find out something more about the work, but you will also find out more about yourself and your own aesthetic preferences. It is best to pick a work of art that you can see for yourself in a gallery, museum, or private collection available to you. If no actual works are available, then choose the very best quality reproduction that you can find.

Be sure to get an illustration of the work you are going to make the subject of your paper. If the work is not illustrated in any reproduction that you can photocopy, you may want to sketch it or arrange to photograph it. One advantage of sketching the work is that it will cause you to focus on the arrangement and quality of the forms in a more precise way.

8. Pick the Approach or Approaches to Art That You Will Use

As your date to begin research approaches, you will want to choose from the three approaches to art that you have studied. What usually works well for an academic paper is a combination of the approaches of formalism and expressionism. You will want to prepare a formal analysis of your work of art, and combine what you learn about the aesthetic appeal of this work from this approach with what you can find out about the meaning of the work through library research. But since many people use the approach of realism, it would be prudent to check first with your professor to make sure that your choice meets with approval. Once you have chosen' your approach or approaches, then you may simply go ahead and analyze your chosen work of art following the guidelines given in the preceding chapters. Or you may use the abbreviated guidelines below for the approaches of formalism and expressionism.

9. If You Have Chosen the Approach of Formalism, Prepare a Formal Analysis of Your Work of Art

A formal analysis is an analysis of the arrangement and quality of the forms of a work of art. The purpose of a formal analysis is to help you to evaluate the aesthetic appeal of the work by carefully looking at the arrangement and quality of the forms.

On the first day that you have set aside for research, you should prepare the formal analysis of the work of art that you have chosen. You may want to review the chapters on formalism, or you may use the following checklist of questions taken from these earlier chapters.

Plan to begin with a half-hour looking carefully at your work and beginning to answer the questions. These questions serve the purpose of focusing your attention on the work of art. You will find that the more you look, the more you will see. You will want to come back to your work of art later on for other half-hour rounds as needed for more careful looking and answering the questions. Not all of these questions will be relevant to the work of art that you are examining.

Questions on Composition

When you are looking at the composition of a work of art, you will find it helpful to ask yourself:

a. Is the composition stable? This refers to your previous experiences of gravity. A composition is stable when it has many horizontal or vertical forms.

b. Or is the composition dynamic? A composition is dynamic when it has many diagonal or curving forms. A composition may have predominantly stable or predominantly dynamic elements, or it may be a balanced mix of the two.

Question on Balance

Here is a useful question to ask concerning the balance of shapes when you are looking at a work of art:

Are the shapes in the composition of your work of art balanced? That is, do the sizes and weights of shapes on each side of the composition seem about equal? The quality of balance is based on your previous experience with gravity.

Questions on Rhythms and Variety

Here are questions to ask yourself as you begin to train your eye to find the ways that order is created in your chosen work of art through the use of rhythms of repeated shapes.

a. Do you see a single shape that is repeated? It may be a simple shape, like a curved line, or a complex shape, like a hand or body. Remember, repeated shapes make rhythms that are pleasing to us as humans. All humans like rhythms because rhythms of repeated shapes create the order that we crave.

b. Are you finding that the repeated shapes are not exact duplicates? Variety contributes to the quality of a work of art.

Questions on the Use of Line

a. Is line used to define the edges of objects? This use of line evokes previous tactile experiences.

b. Is line used to create linear rhythms? This use of line helps create the order that is a part of every work of art.

c. Is line used to create areas of shading? This is a use of line that may add either to the quality of texture or to the three-dimensional quality of objects in a work of art.

Questions on Textures

Here are some questions to help you focus on the tactile qualities of a work of art.

a. Are there actual textures in the work of art? Do you see the actual textures of paint, cloth, or anything else on the surface of your work? These have the power to create tactile experiences and should be taken into account in evaluating the quality of a work of art.

b. Are there simulated textures in the work of art? The way the surfaces of the work are treated can evoke previous memories of tactile experiences. These contribute to the quality of a work of art.

c. Are there numerous contrasting textures in the work, making it sensuous? Real or evoked tactile experiences refer to sensory experiences and are therefore considered sensuous. When a work contains many contrasting textures, it is sensuous.

Questions on Mass (Size and Weight of Objects)

Here are two questions designed to focus your attention on the way in which mass—the size and weight of objects—is indicated in a work of art.

a. Are size and weight indicated by the use of lines around the edges of objects? This is a tactile way to indicate mass.

b. Are the size and weight of an object indicated by the use of highlights and shadows? This is a visual way of indicating mass.

Questions Concerning the Handling of Space

Because space, or more particularly spatial relationships, are so important to us as humans as we move around on our planet, we have many kinds of images relating to space stored in our brains. All of these images relating to space derive from visual experiences provided by light frequencies bouncing off objects and entering the eyes. These are experiences and images that are very important to art, as so many forms in a work of art may evoke these experiences and images. We have seen already in our discussion of the approach of realism that considerations of spatial relationships are important to a human understanding of reality. As a result, there are many questions that you need to ask yourself concerning the handling of space in a work of art:

a. Are objects shown overlapping in the work of art? Overlapping is one spatial cue interpreted by the brain.

b. Are objects elevated above each other to indicate depth? The brain interprets elevated objects as being farther away in space.

c. Are objects shown with highlights and shadows? Objects shown with highlights and shadows are interpreted as being three-dimensional by the brain, and thus inhabiting space.

d. Are objects shown with foreshortening? Foreshortening refers to the changed appearance of an object when it is viewed from different angles. It is one of the cues interpreted by the brain as indicating depth.

e. **Are the objects in different sizes to indicate a spatial relationship?** Relative sizes of objects provide the brain with another cue to space perception, with smaller objects of known size being interpreted as being farther away from the viewer than larger objects.

f. **Is linear or scientific perspective used in your work?** Linear perspective is the combined use of stacked register lines and foreshortened objects to create spatial relationships. Scientific perspective is a linear perspective in which the edges of foreshortened objects at right angles to the register lines in a picture are shown uniformly converging toward one or more vanishing points. Both linear and scientific perspective use the spatial cues of elevated objects and foreshortening that are interpreted by the brain as indications of depth.

To determine whether your work is using scientific perspective, locate the transversals, orthogonals, and vanishing point or points.

Transversals are the stacked register lines in a scientific perspective. Orthogonals are the lines along the edges of objects at right angles to the register lines that, if extended, would uniformly converge at one or more vanishing points. The vanishing point is the point at which the orthogonals of a scientific perspective converge.

g. **Is aerial perspective used in your work?** Aerial perspective makes objects look farther away by showing them in smaller size, with fewer details, paler in tone, and bluer in color. Aerial perspective is sometimes called atmospheric perspective. Smaller size objects are interpreted by the brain as being farther away from the viewer.

Questions Concerning the Handling of Light

Remember that light also refers to the handling of space and color. What you need to consider here are questions referring to brightness in the work of art.

a. **Do the light and dark tones in the work of art gradually grade into each other?** Gradual, gentle transitions from light to dark in the highlights and shadows of a work of art evoke visual experiences of diffuse light, fogs, or smoke.

b. **Do the light and dark tones in the work show a strong contrast?** Strong contrasts of light and dark tones evoke visual experiences in which contrasts are intensified.

Questions Concerning the Handling of Color

There are many aspects concerning the use of color in a work of art. Use the following checklist to help focus your attention on some of these aspects.

a. **Does the work of art show simultaneous color contrasts?** Simultaneous color contrasts refer to the apparent increase in the intensity of two juxtaposed complementary colors.

b. Does the work of art use a mosaic fusion of color? Mosaic fusion refers to the way colors will appear to blend when viewed at a distance.

c. Identify the different hues used in the work of art. Hue means the name of the color.

d. Determine the saturation and brightness for each hue. Saturation refers to the purity of a hue; whether the hue is pale or rich. Brightness refers to the quantity of light present in the hue.

e. How does the work of art use primary or complementary colors? Primary colors in pigments are red, blue, and yellow. In order, their complementaries are green, orange, and violet.

f. How are the warm and cool colors used in the work of art? Warm colors—red, orange, yellow—appear to advance toward the viewer, while cool colors—green, blue, violet—appear to recede. Does the work of art use warm and cool colors to make objects move in space?

10. Select a Method of Researching the Meaning

We suggest strongly that before you undertake to research your work in a library you take the time to look carefully at the work, following the checklist of questions suggested in the formalist approach above. The reason for this is to help you develop your own eye, and not to lean too heavily on the observations of other people. When you do begin your research, remember to limit yourself to approximately one day in the library for each pagelength of the paper. Do not spend much more time than this in research. You will need plenty of time to think about the work and to write your paper.

You will find a large sample of possible methods presented in Chapter 7: illustration, biography, iconography, and the postmodernist methods of structuralism, semiotics, deconstructionism, Marxism, and feminist aesthetics. Each of these methods requires a certain familiarity with its vocabulary, principles, and literature. You will need to acquaint yourself with these before proceeding further. If you are uncertain which would be appropriate, we suggest that you begin with one of the three classic methods of determining meaning: illustration, biography, or iconography.

If you select illustration or iconography as the best methods for you to use to determine the meaning of the work of art, then remember that these methods are based on the concept that the art represents people or objects that can be identified. In order to prepare yourself to identify the people or objects in your work, make sure you have enough information to begin to research them. Try to find out as many of the following facts as possible:

Name of artist or architect (correctly spelled), dates of birth and death, nationality.

Title of the work (also correctly spelled; give variations if there any).

Place the work was made, and present location (if a different place).

Date the work was made (or dates the work was begun and completed).

Medium of the work of art (for example, if a painting, oil on canvas or tempera).

Measurements of the work (in both English and metric systems, if possible).

You can usually find most of this information on the label of the work in the museum, or in the caption of a reproduction of the work, or from dictionary and encyclopedia entries under the name of the artist. If you are working with a contemporary work in a commercial gallery, ask the gallery personnel for the information.

With this information in hand, you will then be ready to research your work of art in a library. Here are a few questions to get you going:

What event or story does this work represent? Check the label or caption for clues to the identity of the event represented. Who are the people in this work and what are they doing? What are their relations with each other? Do their costumes tell you anything about the period the people are supposed to live in? Are they carrying things that can be identified? What is the location represented? Once you identify the event or story, look it up in the appropriate encyclopedia, mythology, or history book to determine how accurately or expressively the artist followed the source.

Here are some other questions to ask to help you understand more about the quality of the illustration or iconography of your work. Are there hidden meanings? Are there other works with similar contents that were made at the same time and place that will give you an insight into your work?

Here are some questions that will help you place the work in context and reveal further levels of meaning. Why was this work made? Who commissioned it? What does this work tell you about the time and place it was made? Is religion or politics or pleasure the main concern of the people of this time? Is this work typical of its place or time? How does this work relate to other works by the same artist?

You will be able to find most of the answers to these and other questions by consulting the standard encyclopedias and art reference books in the reference section in most libraries, and in books and articles that you can locate through the catalog of the library. If in dire need, consult one of the reference librarians.

Keep track of all of the sources that you consult in which you find useful information. Write them down according to the guidelines suggested by your professor. When you have finished your research, you will alphabetize these by author or title to create your bibliography.

11. Organize and Write Your Paper

Organizing and writing your paper requires you to look over the aesthetic analysis and the analysis of meaning that you have prepared, and to combine them into a unified essay on your work of art. Be sure to allow yourself enough time for organizing and writing. We suggested above that you plan for at least two days per pagelength.

You will find that once you have carefully and systematically followed the checklist of questions for looking suggested in the formalist approach above, you will have plenty of your own observations to evaluate the quality of the work.

If you have followed one or more of the suggested approaches to determining the meaning of the work, you will have plenty to say about this aspect of the work. All you need to do now is to think about the points you want to make and how to put them down.

The best papers usually make a few points about a work, and make them well. The points are made with plenty of specific factual observations to back them up.

You may want to use the following basic organizational plan for your paper. This is a standard essay form.

Title: This should include the artist and title of your work of art.

Topic paragraph: This first paragraph should briefly present the main points that you will be making concerning the aesthetic appeal and the meaning of your work. You will then expand upon or support each of these, point by point, one paragraph per point, in the body of your paper.

For example, your topic paragraph might say: "The great aesthetic appeal of Picasso's *Guernica* lies in its complex rhythm of repeated angular shapes, whose sharp angles and austere greys, blacks, and whites reinforce the painful content of the painting: the cruel saturation bombing of a small town in the Spanish Civil War."

You would then devote a paragraph or more to listing all the repeated angular shapes, another paragraph discussing the use of greys, blacks, and whites, and another paragraph or more discussing the destruction of the town of Guernica.

If you need to refer to one or more of your sources, use the footnote form recommended by your professor.

Body of the paper: As discussed above, write a paragraph or more on each point that you make.

Notes: If you need to refer to your sources, remember to use the note form that your professor recommended.

Summarizing paragraph: For your last paragraph, you should summarize the points that you have made in the body of your paper. Now you may want

to look back to your topic paragraph to make sure that it introduces all the points that you actually discussed in the body of the paper.

Bibliography: Make sure that your list is correctly alphabetized by author or title. For the correct format for this bibliography, use the one suggested by your professor.

Illustrations: Use your sketches or reproductions here. Be sure to cite your source.

12. Check Your Paper Carefully Before Turning It In

Reread your professor's assignment to make sure your paper conforms to it. Proofread your paper several times, and correct all your typographical and spelling mistakes.

If you have followed these 12 steps carefully, you will have discovered that you learned so much about the work of art through your focused looking and through your research that the paper nearly wrote itself. That is generally the case when you have plenty to say. It is when you have not looked carefully enough at the work, or when you are relying too heavily on other people's observations, that art criticism is difficult to write. When you have picked a work that strongly appeals to you, and through focused observations and research you are able to figure out the secret of its appeal, this kind of personal evaluation is bound to appeal to your reader as well.

Careful observation works well as a basis for writing other kinds of art criticism. You will find that you can use this basic approach for writing art reviews, as we shall see in the next chapter.

Chapter 9

Writing Art Reviews

The critic isn't a cheerleader. —Thomas Albright

While the approaches to art remain the same, writing art reviews differs from writing for yourself or for an academic requirement, because your time is more limited, and because you are serving different masters.

We will take up the problem of writing under the pressure of a tight deadline first.

Writing Under Pressure

If you are writing for a newspaper or weekly publication, you will have to accommodate yourself to a writing schedule compressed to hours or days, as opposed to the more leisurely weeks or months allotted for writing for an academic course or publications that come out monthly, quarterly, or annually. Remember, before the pressure is on, that your principles of art criticism will remain the same, no matter how tight the deadline. Your responsibility to the works of art, to the artists, to the publication, to your readers, and to yourself as a critic is to use your best judgement to evaluate the works.

Techniques for Coping: Preparation and Concentration

The techniques for coping with the pressure of a deadline include preparation and concentration.

Prepare yourself by considering the different approaches and methods available to you. Understand the basis for your own preferences. Keep your brain stocked with plenty of memory images of works of art to use as comparisons. If you are reviewing a show, do a little research before the opening. Find out the names (with correct spellings) of the artists, and get copies of their resumés, if possible. Arrange to get photographs of the works. If the show has a theme, ask ahead of time to have the theme explained to you. If there is a catalog, get a copy and read it. Make sure you understand any editorial or mechanical requirements set up by the publication for which you are writing.

At the opening of the exhibition to be reviewed, you will want to arrive as early as possible in order to concentrate on the works. Some galleries and museums will permit critics to preview the works. If at all possible, take this opportunity to view the works quietly and at your leisure before the noise and distractions of an opening. Look carefully at each work, and make notes and sketches in order to be able to help you recall later what the work looks like. Kenneth Baker has described this process of concentrated looking as follows: "You go in with your eyes open and wait to see what happens. You wait to see what moves you."

Once you have looked carefully at each work, you will be ready to think about how you want to shape your review. You may at this point want to stop thinking consciously about the review, and allow your brain to

assimilate what you have seen while you turn your attention to other aspects of the opening: the artists, the collectors, other critics, the food and drinks. Listen to what others have to say about the art and compare their observations to your own.

By the time you sit down to write your review, you should have already assimilated what you have seen and you should be ready to make your evaluations. Were the works of art good or not? Would you recommend that your readers go or not go to see this show for themselves? What are your reasons for making these recommendations? These evaluations and recommendations should form the core of your review.

Finding a "Hook" (Catchy Lead)

But now you will need to find a way to introduce your review to catch hold of readers and pull them into reading it. In journalism, the introduction is called the "lead." A really catchy lead contains a "hook" to grab attention. You will find some masterful hooks in reviews by *Time* critic Robert Hughes, by Thomas Albright, critic for the San Francisco *Chronicle* until his death in 1984, and by Kenneth Baker, Albright's successor at the *Chronicle*. Following their examples, your hook might be a provocatively worded evaluation of the artist or exhibit, a general statement, or an historical summary. If you are interested in French critical methods, you might want to begin with a question, as postmodernist critic Rosalind Krauss often does.

Samples of the Evaluation as "Hook"

"No English artist has ever been as popular in his own time, with as many people, in as many places, as David Hockney." Robert Hughes on David Hockney.

"Andrew Wyeth is the grand patriarch of American schlock art." Thomas Albright on Andrew Wyeth.

"If you once thought Vincent the Dutchman had been a trifle oversold, from Kirk Douglas gritting his mandibles in the loony bin at St.-Rémy to Greek zillionaires screwing his cypresses to the stateroom bulkheads of their yachts, you would be wrong. The process never ends." Robert Hughes on an exhibition of Vincent van Gogh.

"If this department had powers of subpoena, assigning grade points or any other sanction, I would order everyone who professes an interest in photography—or in life—to visit the San Francisco Museum of Art to see its exhibition of Henri Cartier-Bresson." Thomas Albright on an exhibition of Henri Cartier-Bresson.

"How is one to begin, in France, to speak of the work of Richard Serra? How to explain the beauty of the work's relentless aggressiveness, its acceptance of the technologically *brut*, to an audience whose ideas of beauty have

been formed in other schools and are, quite simply, invested elsewhere?" Rosalind Krauss on an exhibition of Richard Serra in Paris.

Samples of the General Statement as "Hook"

"Who has not had the feeling, when visiting a museum, of yearning to reconnect with something, if not with art objects, then with human possibilities they symbolize?" Kenneth Baker on an exhibition of Mexican retablos.

"There is a certain subspecies of person who might be categorized as the Professional World Traveller." Thomas Albright on David Hockney.

"Are there two distinct readings to be performed with regard to the work of art, one by the practicing critic, the other by the art historian?" Rosalind Krauss on Jackson Pollack.

Samples of History as "Hook"

"Joan Brown, an artist who has always moved to the sound of a different drummer, became prominent when she was just out of school in the late 1950's, on the coattails of the Bay Area Figurative movement." Thomas Albright on Joan Brown.

"One thinks of Max Beckmann, whose centennial retrospective began in Munich in 1984, and is now at the Los Angeles County Museum of Art, as quintessentially "German." Yet his art had the same relationship (or lack of one) to German Expressionism as Édouard Manet's did to French Impressionism." Robert Hughes on Max Beckmann.

Writing Your Review

The focus of your review might be on the works, on the artist, or on the context of the exhibition. You will have to decide what is the most important aspect of the exhibition. If you have prepared yourself adequately for this review through your research and careful observation of the art, you will have plenty to write about. You will probably find as you are writing that you wish you could go back and take another look at some of the works to confirm your first impression. If at all possible, try to arrange for another look. You may be constrained by a publication deadline. But your review will generally be richer and more accurate the more often you are able to view the exhibition. If you have chosen to focus on the works, you could compare them with other works that you know. If you are focusing on the artist, you could include information from the resumé you took pains to collect earlier, or you could compare the works presently exhibited with earlier works. If you are focusing on the context of the exhibition, you would use any research you have completed on its political and economic background, or you could compare it to other exhibits.

Should You Write a Negative Review?

There is usually plenty to enjoy in the works of art at most exhibitions, and you won't find yourself often needing to write a negative review. Critics who write consistently negative reviews probably need to examine their approaches to art. But if, after careful looking, you find that the exhibition that you are reviewing is without aesthetic merit or has a message that is completely offensive, you should not hesitate to review it as you see it.

The Critic Isn't a Cheerleader

It is not the function of a critic to be a cheerleader, as Thomas Albright said: "The function of criticism is not to seek acceptance—consumer acceptance is the goal of advertising — but to try and provide audiences with insight and illumination, and artists with an honest, hopefully informed reaction so that they will not be merely shouting into the wind—or through a mouthpiece." [1]

Editing for the Readership

A word on the possibility of your review being edited. When you undertake a review, whether as a freelance writer or on assignment, you will need to consider your publisher's requirements. The publisher, in turn, must consider the advertisers and the readership of the publication. There is no need for you to compromise the integrity of your review, but you should exercise common sense. If the readership of your newspaper, for example, is mostly rural with no other access to art than their TV sets, then it doesn't make sense to throw all the latest art jargon into your review without explanation. You don't need to talk down in your review, but you will need to be careful to explain your terms. If you aren't careful to make yourself understood by the readership, you will no doubt find that your editor or the publisher will be eager to set you straight. Dorothy Burkhart, who writes art criticism for the *San Jose Mercury-News*, says: "As an art writer for a newspaper, I make a couple of good points and try to be a bridge between the art and my readers. You don't have to feel you're writing a term paper." [2]

Editing for the Advertisers

It is possible, but unlikely, that another kind of problem may arise out of the economics of art journal publishing. Suppose you are writing a review for a major art journal, and find that the works that you are reviewing are completely without aesthetic merit and are deeply offensive in content. You always have the option to say what you think. Your freedom of speech is

protected by the Bill of Rights. But if the works under review happen to be by an artist who is under contract to a gallery that is a major advertiser with your publication, your review may be at risk of being heavily edited or thrown out. The Bill of Rights doesn't guarantee that anyone has to *buy* your speech.

This kind of editing for economic reasons seldom occurs, because few galleries outside of New York and Los Angeles have advertising budgets that would influence a publisher, and most critics exercise common sense by keeping out of situations where their principles would come in conflict with someone's profit-making motive. One option in this case, for example, would be to go ahead and write a truthful review of the horrors as you see them, and then take your review to another publication.

Editing is likely to be the least of your problems as a reviewer. A more realistic problem for critics who regularly write reviews is continually finding something fresh to say about art. However, if you keep going to exhibitions and museums, keep talking to artists, gallery owners, museum curators, and college professors, and keep researching the politics and economics of the art world, you will never run out of material for your reviews. For variety, regular reviewers sometimes turn to writing satires, histories, biographies, or philosophical pieces about the nature of art and art criticism. But they always return to the foundation of art criticism: the evaluation of works of art.

The Future of Art Criticism as a Profession

There is much room for improvement in professional art criticism as it is currently practiced. Art critics in the United States today appear to fall by their training into two categories: most are newspaper reporters with training in journalism who have been assigned the arts as their beat; a few are academics with training in the arts who write reviews as a sideline. A very few are those with training in the arts who are now professional art critics for national publications. Examples of good art criticism, meaning reviews that attempt to evaluate and not just to describe, account for only 2.7% of all arts coverage in 50 newspapers surveyed for the National Council on the Arts, as cited by Ann McQueen in a 1990 report for the Visual Arts Program of the National Endowment for the Arts. [3]

No doubt the bulk of the remaining arts coverage in those 50 newspapers was written by reporters who had to meet a deadline and, without any guide to art criticism, fell back on simple description. One solution to the problem of improving art criticism is to provide education for the reporters assigned to the arts. But not many reporters are going to want to take an average of seven years out of their lives and spend $50,000 or more in tuition fees to earn a Ph.D. in art history. Some reporters with a natural bent for the arts are able to learn on the job if they live long enough, as did Thomas Albright during his 27-year stint at the San Francisco *Chronicle*, where he covered all the arts, including jazz music. For other reporters, conferences,

forums, grants, fellowships, and internships to encourage further training could be workable solutions to improving the quality of their art criticism. The Critics' Conference sponsored in October 1991 by the National Gallery of Art in Washington, D.C. is an example of a recent professional conference for critics. To give you an index of current concerns with criticism at the national level, the panel topics at this conference included: *The Critic and the Editor: Reporting and Criticism; The Critic, the Artist, and Ethics; Art Criticism in the Age of Globalism; Conservation and the Traveling Exhibition; The Critic and the Community; Museums and Exhibitions; Professional Development: Ideas for Improving the Conditions and Options for Criticism around the County.*

Art criticism serves an important function in the nation, as noted in McQueen's report: "Criticism functions primarily as dialogue between writer and reader about standards of excellence. This kind of analysis, by providing an exposition and interpretation of a particular contemporary artwork, gives the adult audience the means for thinking independently about other artworks. Criticism can also broaden the adult audience's understanding of, and support for, the arts by providing an introduction to aesthetic experience previously outside their participation." [4]

Despite this important national function, there appear to be no academic programs that offer degrees in art criticism. As one critic remarked: "Art criticism is not really a legitimate profession—you can't get a degree in it." [5] Funding to support professional development in art criticism remains sketchy. Improvements in academic training and in professional development are much needed, although there are at present a few opportunities for professional development scattered around the country.

For critics interested in these professional development opportunities, here are the institutions listed in McQueen's report in 1990 to the Visual Arts Program that provide competitions, grants, and awards to art critics:

"Articulating the Arts Competition"
Arts Insight, 47 S. Pennsylvania St., Ste. 403
Indianapolis, IN 46204.
Awards of $150 available to Indiana critics only.

Center for Advanced Study in the Visual Arts
National Gallery of Art
Washington, DC 20565
Fellowships for critics with a doctorate or equivalent.

Center for Arts Criticism
2402 University Ave.West, Ste. 208
St. Paul, MN 55114
Provides services and professional career opportunities for critics in the Upper Midwest.

The Reva and David Logan Grants in Support of
New Writing on Photography
Photographic Resource Center
602 Commonwealth Ave.
Boston, MA 02215
Grants of $250 plus publication of review.

John McCarron New Writing in Arts Criticism Grants
San Francisco ARTSPACE
1286 Folsom St.
San Francisco, CA 94103
Awards up to $5000 plus publication of review.

National Endowment for the Humanities
1100 Pennsylvania Ave., NW
Washington, DC 20506
Grants for projects on historical criticism.

Ohio Arts Council
727 East Main St.
Columbus, OH 43205
Fellowships up to $50,000 in critical writing category of annual creative writing grants.

Vermont Council on the Arts
136 State St.
Montpelier, VT 05602
Awards of $250 available to Vermont critics only.

Washington State Arts Commission
110 9th and Columbia St.
Olympia, WA 98504–4111
Grants available to critics.

The Burning Typewriter and the Critic
as Guest at the Feast of Art

Two works of art with images that may amuse, guide, and encourage the art critic. One is the burning typewriter in Leopoldo Maler's *Hommage* **(Figure 9.1)**, whose carriage is permanently aflame with gas jets. May all your reviews burn with a hard gem-like flame! The second image is the ceramic tongue-in-cheek portrait of the artist as a chef in the work *Overcooked* by the California sculptor Robert Arneson **(Figure 9.2)**, reminding us that while artists are the chefs who cook up feasts for the eyes, and certainly deserve to be placed on a pedestal, art critics have the pleasant duty of attending these feasts, and enticing others to sample the best of the fare. Or posting warnings where the critic thinks the fare is unfit. For the opportunity to read selected examples of art criticism, turn to the last chapter.

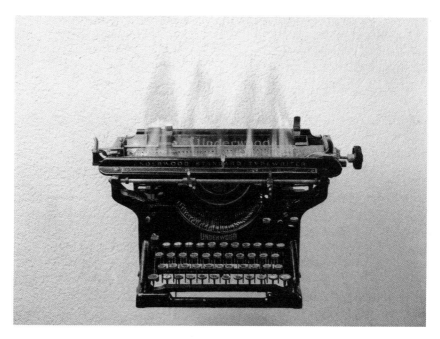

Figure 9.1 ▼ Leopoldo M. Maler, *Hommage* (Burning Typewriter) 1974. (By kind permission of the Hess Collection, Napa.)

Figure 9.2 ▼ Robert Arneson, (American), *Overcooked,* 1973. (Terra cotta, Crocker Collection; Crocker Art Museum, Sacramento, California.)

Notes

[1]Thomas Albright, "The Critic Isn't a Cheerleader," in *On Art and Artists: Essays by Thomas Albright*, edited by Beverly Hennessey (San Francisco: Chronicle Books, 1989), p. 177.

[2]Dorothy Burkhart was speaking as a panelist in a forum on art criticism, "Critical Responsibility," sponsored by the San Francisco Art Dealers Association, July 10, 1991.

[3]Ann McQueen, Fellow in Arts Administration, Visual Arts Program, *A Report on Funding Policy and Programming for Critical Writing in the Visual Arts*, December 14, 1990 (Visual Arts Program, National Endowment for the Humanities, Grant Number 90-3051-0039), p. 18.

[4]Ibid., p. 3.

[5]Christine Tamblyn, correspondent for *ArtNews*, speaking as a panelist at the forum, "Critical Responsibility," sponsored by the San Francisco Art Dealers Association, July 10, 1991. However, if you have $15 and a sense of humor, you can apply for a mail-order honorary Ph.D. in Art Criticism from the unaccredited Institute of Art Criticism at 2812 Pearl St., Austin, TX 78705, as advertised in *Artweek*.

Further Reading

Albright, Thomas. *On Art and Artists: Essays by Thomas Albright*, edited by Beverly Hennessey. San Francisco: Chronicle Books, 1989.

Hughes, Robert. *Nothing If Not Critical: Selected Essays on Art and Artists*. New York: Knopf, 1990.

Krauss, Rosalind E. *The Originality of the Avant-Garde and Other Modernist Myths*. Cambridge, Mass.: MIT Press, 1985.

Chapter 10

▼ ▼ ▼ ▼ ▼

Portfolio of Art Criticism

This final chapter provides you with the opportunity to examine short samples of art criticism written by experienced critics, using different approaches to the works of art. You will find reviews below of individual works, group shows, and the works of one artist in a group show. These samples may be used as models and inspirations for your own art criticism, but don't stop here. Consider these samples as the beginning of your own collection of the pieces of art criticism that you admire.

i. Sample Art Criticism: Realism

E. H. Gombrich on the Mona Lisa *(1503) by Leonardo da Vinci*

One of the most influential of the European art historians, Ernst Gombrich received his training in Austria and then emigrated to England where he was Director of the Warburg Institute and a professor at the University of London for many years. His studies and publications have had a great impact on generations of art historians in England and the United States. Gombrich's approach to art is the traditional one of realism, modified with occasional excursions into the expressionistic approach of iconography. His response to the *Mona Lisa*, that was prepared for his introductory survey called *The Story of Art,* is a model of the approach of realism. Gombrich speaks of the painting as if it were a living woman.

> "What strikes us first is the amazing degree to which Lisa looks alive. She really seems to look at us and to have a mind of her own. Like a living being, she seems to change before our eyes and to look a little different every time we come back to her. Even in photographs of the picture we experience this strange effect, but in front of the original in the Paris Louvre it is almost uncanny. Sometimes she seems to mock us, and then again we seem to catch something like sadness in her smile. All this sounds rather mysterious, and so it is; that is so often the effect of a great work of art. Nevertheless, Leonardo certainly knew how he achieved this effect, and by what means. That great observer of nature knew more about the way we use our eyes than anybody who had ever lived before him."

From E. H. Gombrich, *The Story of Art* (Oxford: Phaidon Press, 1981, 13th ed.), pp. 227–228.

ii. Sample Art Criticism: Formalism and Expressionism

Laura L. Sueoka on Woman *(1950) by Willem de Kooning*

This art criticism, written by a staff member of the San Francisco Museum of Modern Art for a catalog of the permanent collections, demonstrates a classic use of two approaches: the approach of formalism, as seen in the first

paragraph, and the expressionistic approach of iconography, as seen at the end of the first paragraph and in the second paragraph.

"Presented in a monumental frontal manner, the figure fills up the pictorial space, powerfully engaging the viewer. Broad sweeps of chalky white and fleshy pink pigment suggest limbs and voluptuous breasts, while a network of lines and planes activates the facial features and wide-eyed gaze. The curve of a shoulder and the blond mane of hair are defined by viscous brushstrokes of yellow color. Riveting and provocative, the arresting power of *Woman* lies not only in the disquieting image, but in the manner of execution whereby tension is created through the rubbed, scumbled, dripped, and splattered surfaces.

For de Kooning, the image of the woman represented the opportunity to express an ancient theme in contemporary terms. Fascinated by the banal in American advertising and intrigued by the universal images that inundated society, de Kooning responded with his creation of a twentieth-century goddess, not a softly rounded idol of fertility, but a garish, vulgar, and comic siren of the modern industrial age."

Entry for Willem de Kooning's *Woman* in the catalogue: *San Francisco Museum of Modern Art: The Painting and Sculpture Collection* (New York: Hudson Hills Press, 1985), p. 158.

iii. Sample Art Criticism: Formalism

Hilton Kramer on the exhibition: Degenerate Art

Hilton Kramer, editor of *The New Criterion*, a monthly journal of cultural affairs that includes reviews and articles on art, poetry, literature, theater, and music, also writes reviews for the journal. While Kramer's review of the recently revived Degenerate Art exhibition—originally organized by Adolph Hitler to mock and destroy modernist works of art—mostly talks about Nazi oppression, it also provides an evaluation of the art based on the formalist approach, speaking as it does of the "quality" of the works.

"This is an exhibition about an historic attempt to destroy art, and while it offers us some welcome moral gratification to see how much of the art actually survived this concentrated assault, the art itself—or a very large part of it, anyway—is now so familiar to museumgoers that it cannot give us much in the way of a fresh revelation.

Then, too, there is the problem of the art itself. While there is no shortage of masterworks in the show, it must be acknowledged that there is no shortage of works of poor quality as well. It could scarcely have been otherwise. The Nazi bureaucrats who organized the Munich show were anything but connoisseurs of modernist art. Like the ideological bullies of our own time, who insist on judging every work of art by some standard of political correctness, the Nazis selected work for the "Degenerate Art" show on the basis of subject matter or race or some other non-aesthetic standard. Some of these objects turned out to be works of genius, but many others were not."

Published in *The New Criterion* (October 1991), pp. 8–9.

iv. Sample Art Criticism: Expressionism (Biography)

Robert Hughes on Pygmalion and Galatea (1910)
by Auguste Rodin

An Australian who trained as an artist and wrote books on Australian art and the themes of heaven and hell in art before coming to the United States, Robert Hughes has the artist's eye for art and the scholar's knowledge of the history of art to bring to his reviews. Since 1970, Hughes has written reviews for *Time* magazine in New York as a staff critic, and occasionally for other publications such as the *New York Review of Books*. His book on modern art, *The Shock of the New* (1981) was made into a widely publicized television series, with himself as commentator, and he recently published a collection of his reviews. Because of his experience and exposure, Hughes is probably the best-known art critic in the United States today.

As a critic, Hughes is thoroughly competent to evaluate the quality of the works of art he reviews from the approach of formalism, when he chooses. Here he is on Paul Gauguin's use of color: "If there is an absolute originality in Gauguin, it lies in his color, for which no amount of reproduction prepares you. It is saturated, infinitely subtle, full of stately assonances and risky contrasts." But usually he prefers to focus on various aspects of expressionism in his approach to the works of art: the social, political, or economic context of the work of art, or the work of art as expressive of the biography of the artist. In the abridged review printed here, Hughes uses the expressionistic approach of biography to discuss the connection he sees between the French sculptor Rodin's erotic passions and his art.

> "Rodin had very few inhibitions; flesh, both his own and others', was a source of inexhaustible fascination to him, and the erotic fury one often senses in his squeezing and manipulation of the clay was by no means a metaphor.
>
> The myth of Pygmalion and Galatea (the sculptor falling in love with the figure he had carved) had vast resonance for Rodin; in his marble *Pygmalion and Galatea*, 1910, the girl emerging from the stone seems literally shaped by the carved sculptor's own passion, as though the consciousness and dream, body and effigy, art and life, subject and object could all be packed into one erotic metaphor."

From Robert Hughes, *Nothing If Not Critical: Selected Essays on Art and Artists* (New York: Knopf, 1990), p. 130.

v. Sample Art Criticism: Expressionism (Biography)

Peter Plagens on Frida Kahlo

Peter Plagens, art critic for *Newsweek*, is also a practicing artist and the author of *Moonlight Blues: An Artist's Art Criticism* (1986). The following abridged review of an exhibition of the works of the Mexican surrealist, Frida Kahlo, primarily demonstrates the expressionistic approach of biography, as most of the material printed here discusses the details of the life of the artist. The point made by this review, which was jointly prepared with other *Newsweek* staff members, is that the lurid details of Kahlo's biography supply the main reason for the public's interest in her work. The review, however, does not provide a correction of this view by actually evaluating Kahlo's works. There is only one sentence given over to a discussion of the works of the artist. This uses "spiritual intensity," "visual invention," and technical adroitness" as the criteria for evaluation. Spiritual intensity refers to an expressionistic approach, visual invention means novelty, and technical adroitness refers to technique.

> "In the case of Kahlo, weighing the quality of the art against the saga of the artist is particularly complicated. Her life story, now the stuff of hagiography, strikes about every emotionally correct nerve in the contemporary art world. Kahlo (1907–54) was a faux-naïf surrealist who specialized in confessional self-portraits. The daughter of a German Jewish father and a Mexican mother, she lived an adult life in the shadow of husband, Diego Rivera, the muralist who was a Mexican national hero. He was gross (300 pounds) and psychologically abusive (he seduced her younger sister, for instance). But the bisexual Frida retaliated with affairs of her own (with Leon Trotsky, for one, and even some of the women with whom Rivera was dallying).
>
> But are the paintings *that* good?
>
> The best Kahlos exude a spiritual intensity inextricably bound to genuine visual invention and technical adroitness. But a large part of the audience's infatuation with Kahlo comes from her pictures' stories."

Published in *Newsweek* (May 27, 1991), pp. 54–55.

vi. Sample Art Criticism: Expressionism (Iconography)

Arthur C. Danto on Jeff Koons in the Whitney Biennial

Art critic for *The Nation* and married to a painter, Arthur Danto is by training a philosopher who teaches philosophy at Columbia University in New York. Danto makes it clear that he is writing from the approach of expressionism: "Criticism, as I practice it, consists in finding how the ideas expressed by the works I discuss are embodied in them to the degree that I can discover this." Besides ideas, Danto occasionally discusses art from the ap-

proach of realism. For example, in a review of Paolo Veronese's works, Danto is full of praise for "how Veronese managed to caress the eye with skin and flesh as warm and radiant as skin and flesh are in great beauties." But for an art critic, he seems curiously devoid of the "eye" for art that comes from careful attention to the quality and arrangement of forms in the works. He makes up for this void with a wealth of informational commentary pulled from his vast mental files of philosophy and history. While Danto seeks for the ideas embodied in art, he disapproves of most of the images of contemporary art, and frequently indulges himself with reviews filled with gleeful invective.

Danto particularly dislikes art that plays with the idea of the American obsession with consumer goods, as you will see in the following passage, abridged from a review of the work of contemporary artist Jeff Koons as it appeared in a Whitney Museum Biennial show in New York. Perhaps if Danto had been able to comment on Koons's arrangement of forms, the review might not have been so devastatingly negative.

> "There is an order of imagery so far beyond the pale of good or even bad taste as to be aesthetically, and certainly artistically, disenfranchised. Objects that belong to it are too submerged even to be classed as kitsch, for kitsch believes itself to be the high taste it instead pathetically parodies. I am referring to such things as cute figurines in thruway gift shops; the plaster trophies one wins for knocking bottles over in cheap carnivals; marzipan mice; the dwarves and reindeer that appear at Christmastime on suburban lawns or the crèche figures before firehouses in Patchogue and Mastic; bath toys; porcelain or plastic saints; what goes into Easter baskets; ornaments in fishbowls; comic heads attached to bottle stoppers in home bars. Koons has claimed this imagery as his own, has taken over its colors, its cloying saccharinities, its gluey sentimentalities, its blank indifference to the existence and meaning of high art, and given it a monumentality that makes it flagrantly visible, a feast for appetites no one dreamt existed, and which the art world hates itself for acknowledging."

Reprinted in Arthur C. Danto, *Encounters and Reflections: Art in the Historical Present* (New York: The Noonday Press, 1990), pp. 280–281.

vii. Sample Art Criticism: Expressionism (Iconography)

Kenneth Baker on David and Goliath IV by Tony Labat

Kenneth Baker, the art critic for the San Francisco *Chronicle* who used to write for *Artforum* in New York, takes pains to make his reviews accessible to the readership of this conservative Northern California paper. Baker often carefully sets the political and economic context for his reviews, explaining the selection of artists and who paid for the show he is writing about. This research sometimes leaves him with little space to evaluate the art. While possessed of the excellent "eye" that comes from a thorough appreciation of

the quality and arrangement of the forms, Baker generally chooses to focus on his responses to the meaning of the forms. After more than two decades of reviewing, Baker is also able to draw from his own personal databank of visual memories to make useful comparisons with the work under review, as he does here with his memories of Labat's earlier works.

Baker frequently goes on out-of-town assignments for the *Chronicle* to review important shows around the country. In the following passage, he is writing from Washington, D.C., where he went in July 1991 to review the annual awards show at the Hirshhorn Museum and Sculpture Gallery. Before presenting the response printed below, Baker described the work in question, noting that it had three parts: a padded yellow cubical box whose sides unfold into a cruciform shape; another box containing a video and monitor; and a large one-way mirror with a blue vinyl cushion on the opaque side.

> "Walk around to the dimly lit transparent side of the mirror (where an identical blue cushion sits) and you seem to see the same pairing of real and illusory cushions, minus your own reflection.
>
> Instead of yourself, you see other viewers passing the mirror, unaware of being watched.
>
> And instead of seeing a reflection of the cushions at your feet, you see it redoubled by the one on the far side of the mirror, reality imitating illusion, instead of the reverse.
>
> Knowing that Labat's work often toys with the positions of the artist, the artwork and its spectators, both in the immediate exhibition situation and in the larger world, I suspect that this may be the referential key to *David and Goliath IV* as well.
>
> The situation he sets up is snarled with possible meanings, from the hint of martyrdom in the padded yellow cross to the reversals of reality and illusion, self-inspection and surveillance in the one-way mirror. But this is far from the most accessible piece by Labat that I have seen."

From the review of the Awards 10 at the Hirshhorn Museum and Sculpture Gallery, Washington, D.C., published in the San Francisco Sunday *Chronicle* (July 21, 1991), Datebook, pp. 42–43.

viii. Sample Art Criticism: Postmodernism

Rosalind E. Krauss on Pierre Daix's catalogue, Picasso: 1907–1916.

Rosalind Krauss, an art historian at Hunter College in New York and a former writer for *Artforum* who co-founded the periodical *October*, is thoroughly familiar with contemporary French criticism, in particular, the deconstructionism of Jacques Derrida. As an art critic, Krauss, like the French critics, is apparently often more interested in methodology than in the art under review. In the sample printed below, Krauss focuses on the method

used by Daix in his catalogue of Picasso's work from 1907–1916. You will be able to note for yourself that Krauss is primarily interested in an intellectually rigorous clarity of methodology, and not in the works of art discussed by Daix. The methodology Krauss is interested in expounding here is based on the French linguistics theory of Ferdinand de Sassure. (The review as printed here is abridged.)

> "Daix's suggestive text expands the somewhat limited art-historical vocabulary for describing what transpires with the advent of collage, for Daix insists on characterizing collage-elements as signs—not simply in the loose way that had occurred earlier on in the Picasso literature—but in a way that announces its connection to structural linguistics.
>
> But there is nowhere in Daix's exposition, a rigorous presentation of the concept of the sign.
>
> If we are really going to turn to structural linguistics for instruction about the operation of the sign we must bear in mind the two absolute conditions posited by Sassure for the functioning of the linguistic sign. The first is the analysis of signs into a relationship between signifier and signified (s/S) in which the signifier is a material constituent (written trace, phonic element) and the signified, an immaterial idea or concept."

Reprinted as "In the Name of Picasso," in Rosalind E. Krauss, *The Originality of the Avant-Garde and Other Modernist Myths* (Cambridge, Mass.: MIT Press, 1985), pp. 32–33.

Glossary

Aesthetics The branch of philosophy that is concerned exclusively with all the arts. Like the word "art," the term "aesthetics" has deep roots in our cultural history. It comes from a Greek word that means "to perceive."

Aerial perspective (sometimes called **atmospheric perspective**). System of perspective that takes into account the light-scattering effect of distance and makes objects look farther away by depicting them with fewer details and bluer in color.

After images A visual phenomenon, in which, if you stare at an image in a particular color for ten seconds or more, and then look at a blank white area, you will see an image, called the after image, in the original image's complementary color. The phenomenon is caused by sensory fatigue.

Art May be defined in terms of three approaches: realism, formalism, and expressionism. Realism is the representation of reality. Formalism refers to the quality and arrangement of the forms of art. Expressionism is the expression of meaning.

Art criticism The evaluation of art.

Asymmetry The arrangement of forms in a work of art so that the right half is very different from the left side in size, shape, and weight.

Atmospheric perspective (usually called **aerial perspective**) System of perspective that takes into account the light-scattering effect of distance and makes objects look farther away by depicting them with fewer details and bluer in color.

Balance The arrangement of forms in a work of art so that the right half seems to weigh the same as the left half.

Biography The method of finding meaning in a work of art that is based on the concept that the work expresses some aspect of the personal life of the artist.

Brightness (also called **luminance**) The quantity of light present in a color.

Chiaroscuro (pronounced key-are-uh-**skoor**-oh) A strong, dramatic contrast of light and dark tones, usually applied to paintings and the graphic arts. From an Italian term that means "light/dark."

Color The different wavelengths of light as perceived by the cones in your eyes. Strictly speaking, objects don't have color. We see a specific color in an object when a certain wavelength of light bounces off it and is perceived by the cones.

Color constancy The ability of the human eyes to adapt the color they are looking at to remain constant to the color that the sensory memory tells them it ought to be.

Color movement The visual phenomenon in which colors at the high end of the spectrum (red, orange, yellow) appear to advance toward the viewer, and colors at the low end of the spectrum (green, blue, violet) appear to recede from the viewer. This phenomenon is caused by the different lengths of the light waves as the cones in the retina focus on them.

Color temperature The visual phenomenon in which colors at the high end of the light spectrum (red, orange, and yellow) are perceived as warm colors, and colors at the low end of the spectrum (green, blue, and violet) are perceived as cool colors. The reason for this phenomenon is not known, but may be related to the fact that red wavelengths in the light spectrum (7600–6500 A) are very close to and in fact slightly overlap the range of infared wavelengths that the sensory receptors in our skin perceive as heat (10000–7500 A).

Complementary colors (also called **opposite colors**) In pigments, the colors which, when mixed, will produce grey or black. For red pigment, the complementary color is green; for blue pigment, the complementary is orange; and for yellow, the complementary is violet. In lights, the colors which, when mixed, will produce a white light. The complementary colors for the primary colors in light are as follows: for a red light, the complementary is cyan blue (blue-green); for blue light, the complementary is chrome yellow; and for green the complementary is magenta red (blue-red).

Composition The arrangement of forms in a work of art to appear stable or dynamic. These qualities refer to your previous sensory experiences with gravity and motion. Horizontal and vertical forms appear stable; curved and diagonal forms appear dynamic.

Cones Sensory receptors located mostly at the center of the retina of the eye that work best in strong light, and are the only receptors that are capable of sharp focus and color vision.

Deconstructionism A method of approaching the meaning of art by displacing or deconstructing the traditional borders of art and theory, developed by the French philosopher, Jacques Derrida.

Expressionism The approach to art that is concerned with the expression of meaning.

Feminist Aesthetics A political method of approaching the meaning of art that is concerned with the political empowerment of current women artists as well as the recognition of women's art and women's approaches to art.

Foreshortening The changed appearance of an object when it is viewed from different angles.

Formal analysis The analysis of the arrangement and quality of the forms of a work of art.

Formalism The approach to art that is concerned with the quality and arrangement of forms.

Forms The shapes of art. The concept of forms refers to the arrangement and quality of the forms or shapes of a work of art. The arrangement of the forms means their composition, balance, and rhythms. The quality of the forms means the handling of their line, texture, mass, space, light, and color.

Ground line (also called **register line**) A line painted at the bottom of the picture upon which all the figures are located. It anchors the figures in space and provides a way for creating relationships in space between two figures.

Highlighting (also called **modeling**) The use of light tones in a work of art to suggest the falling of light on a surface and the use of dark tones to suggest shadows.

Hue The particular wavelength of the spectrum, meaning the name of the color: red, orange, yellow, green, blue, and violet.

Iconography The study of the symbolic meaning of people or objects. It carries the approach of illustration to a more profound level.

Idealism A philosophical view of reality as mental or spiritual conceptions called Ideals. From "idea," a mental conception.

Illustration A method of approaching the meaning of a work of art that is concerned with identifying the people or objects represented in the work.

Intensified light-dark contrast The visual phenomenon in which the contrast between juxtaposed dark and light tones in a work of art appear to become stronger or intensified. The phenomenon occurs through a process of inhibition of the sensory receptors.

Light The visible band of the vast spectrum of different radiations, or electromagnetic wavelengths, bombarding our planet daily from the sun and the rest of the universe. Visible light is only a narrow segment of this spectrum. In a work of art, light means the use of highlights and shadows. Light, of course, may also be perceived as color in a work of art.

Line A shape like a thread or band in a work of art. The use of line in a work of art to define the edges of forms is one way in which our previous tactile experiences are evoked.

Linear perspective (also called **perspective**) Linear perspective is the combined use of stacked register lines and foreshortened objects to create spatial relationships.

Luminance (also called **brightness**) The quantity of light present in a color.

Marxism A political method of approaching the meaning of art that is based on Karl Marx's view of history as a class struggle, with art to be evaluated for what it contributes to the ultimate victory of the proletariat.

Mass A solid object in a work of art that has size and weight. We learn about solid objects through a combination of sensory experiences that is partly tactile and partly visual.

Modeling (also called **highlighting**) The use of light tones in a work of art to suggest the falling of light on a surface and the use of dark tones to suggest shadows.

Mosaic fusion The apparent blending of colors, even opposite colors, when viewed at a distance.

Opposite colors (also called **complementary colors**) In pigments, the colors which, when mixed, will produce black. For red pigment, the complementary color is green; for blue pigment, the complementary is orange; and for yellow, the complementary is violet. In lights, the colors which, when mixed, will produce a white light. The complementary colors for the primary colors in light are as follows: for a red light, the complementary is cyan blue (blue-green); for blue light, the complementary is chrome yellow; and for green the complementary is magenta red (blue-red).

Orthogonals In a work of art with a linear perspective, the lines along the edges of objects at right angles to the register lines that, if extended, would uniformly converge at one or more vanishing points.

Overlapping Placing one form on top of another form in a work of art to indicate that one form is in front of the other. A very old method for creating relationships in space.

Perspective The creation of spatial relationships in a work of art through a variety of methods (also see **linear perspective, scientific perspective, aerial perspective,** and **atmospheric perspective**), which may include foreshortened objects, register lines, or making the objects smaller, with less detail and bluer in color.

Phenomenology (pronounced fee-nom-in-ol-oh-gee) A philosophical view of reality as something that can be perceived with the senses, for example, an object that you can see or touch. From "phenomenon," something that can be observed.

Postmodernism In general, the methods of art criticism developed in reaction against the approach of formalism.

Predictability The use of nearly identical forms in the rhythms of repeated forms in a work of art. Considered less desirable than variety.

Primary colors The hues that can be mixed to make up all the other colors. There are several sets of primary colors, depending on whether pigments or lights are used. If pigments, the primary colors are red, blue, and yellow. These can be mixed with each other or with dark and light tones to produce almost any hue on earth. If lights, the primaries are either red, green, and blue, or the mixtures of any two of these: magenta (red and blue), cyan (blue and green), and yellow (red and green).

Purity (also called **saturation**) The amount of hue in a color. We use the hues we perceive in a rainbow as the standard for saturated or pure hues. Hues can range from pale to rich in saturation or purity.

Realism The approach to art that is concerned with art as the representation of reality.

Register line (also called **ground line**) A line painted at the bottom of the picture upon which all the figures are located. It anchors the figures in space and provides a way for creating relationships in space between two figures.

Rods Sensory receptors that are spread all over the retina and perceive light only, not color. Rods operate best in dim light, and are especially sensitive to flicker and motion.

Rhythms The orderly repetitions of similar forms in a work of art. Unlike the responses to composition and balance, our aesthetic response to the rhythms of repeated forms in a work of art appears to be based on a human need for order, rather than on a previous sensory experience. We believe that the need for order is fundamental to human psychology, and that order is basic to human art.

Saturation (also called **purity**) The amount of hue in a color. We use the hues we perceive in a rainbow as the standard for saturated or pure hues. Hues can range from pale to rich in saturation.

Scientific perspective A linear perspective in which the edges of foreshortened objects at right angles to the register lines in a picture are shown uniformly converging toward one or more vanishing points.

Semiotics A method for analyzing the structure of a work with a view to understanding the whole complexity of meaning communicated. Semiotics is the science of signs, the systems by which humans communicate that include language, auditory communication, gesture language and writing, and visual communication.

Sfumato (pronounced sfoo-**maht**-oh) A very gradual and gentle transition from light to dark in a work of art. Usually applies to paintings or the graphic arts. From the Italian term for "smoke."

Simultaneous color contrast The apparent increase in the intensity of two complementary or opposite colors when they are placed next to each other. This contrast effect is produced through a process of inhibition similar to that producing intensified light-dark contrasts.

Space The spatial relationship of objects to each other and to the viewer. We don't really see space, but objects in relation to each other and to ourselves.

Structuralism A method of determining meaning in a work of art by analyzing out its components and comparing these to the components of other aspects of culture. The theory of anthropology developed by the French anthropologist, Claude Lévi-Strauss, in which cultural institutions are broken down into separate elements, and then examined to define their relationships.

Symmetry The arrangement of forms in a work of art so that the right half seems to be exactly the same in size and shape as the left side.

Texture The tactile quality evoked by the way the surfaces of objects in a work of art are given highlights and shadows. The textures in a work of art may be *real*, that is, the work of art may really have surfaces that feel as well as look fluffy like hair or hard like stone. But more often, the textures in a work of art are *simulated*, that is, through the use of line or light, the textures look real, but if you touch them, do not feel like the textures they mimic.

Tactile experiences The sensory experiences of touch. Tactile experiences originate in the way we learn about the surfaces of objects by touching them with our hands or brushing against them with other parts of our skin. The handling of line, texture, and mass evoke the memories of previous tactile experiences.

Transversals The stacked register lines in a scientific perspective. Transversals create a recession into space.

Vanishing point The point at which the orthogonals of a scientific perspective converge.

Variety The use of forms which are somewhat similar but not identical in the rhythms of repeated forms in a work of art. Considered more desirable than predictability.

Visual experiences The sensory experiences of sight. The handling of space, light, and color in a work of art evokes previous visual experiences. The handling of color, alone of all the aspects of form, may also create an immediate visual experience. All of these sensory experiences of sight depend upon the way the eyes respond to the stimulus of light.

Work of Art Anything people arrange into order. Judgment is needed to determine which things will repay close attention.

Index